M000289907

LOST SKI AREAS

of

Colorado's Front Range

— and —

Northern Mountains

LOST SKI AREAS

of

Colorado's Front Range

—— and ——

Northern Mountains

CARYN & PETER BODDIE

THE
History
PRESS

Published by The History Press
Charleston, SC 29403
www.historypress.net

Front cover, bottom: Skiers explore Rock Creek Ski Area. *Courtesy U.S. Forest Service*; *top, middle*: skier rides chairlift on Emerald Mountain. *By Reginald "Rex" Gill. Courtesy, Tread of Pioneers Museum, Steamboat, Colorado.*
Back cover: Fashionable skiers strike a pose at Berthoud Pass Ski Area. *Courtesy U.S. Forest Service.*

First published 2014

ISBN 978-1-5402-1174-3

Library of Congress Control Number: 2014951882

Notice: The information in this book is true and complete to the best of our knowledge. It is offered without guarantee on the part of the author or The History Press. The author and The History Press disclaim all liability in connection with the use of this book.

For the fun of skiing, for the people of skiing, for the sport of skiing, praise God.

Contents

Foreword

For many, Colorado and skiing are synonymous. Visions of abundant light, powdery snow at large, expansive ski resorts are what most people see when they think of Colorado's ski industry. These days, most people experience skiing in the state on a handful of mega resorts mostly along or near the I-70 corridor, but this was not always so. Not long ago, smaller local ski slopes dotted Colorado's mountains and hills. Many were unnoticed by those outside the immediate community. Others aspired to attract ski tourists traveling either from Colorado's Front Range cities or visitors to the state. Today, save for a handful, these small ski areas have disappeared, leaving only occasional abandoned lifts and tows and many cherished memories.

Growing up in Colorado Springs in the 1970s and early 1980s, my earliest memory of skiing was the view I had of Ski Broadmoor. Every winter, three white strips appeared on the short, carved-out runs at the base of Cheyenne Mountain. After the sun set in the evening, the lights of Ski Broadmoor's slopes would shine into our dining room as hundreds of local families enjoyed sliding down its illuminated, icy man-made snow. This was not the only nearby ski area for those of us living in the shadows of Pikes Peak and Cheyenne Mountain. Driving up U.S. 24 to Santa's Workshop, located on the north slope of "America's Favorite Mountain," I knew that our destination was near when the chairlifts of the Pikes Peak Ski Area came into view.

Other lost ski areas that I remember as long-lost landmarks are Arapahoe East and Berthoud Pass. The chairlifts of Arapahoe East, visible from I-70 just west of Denver near Genesee, signaled our ascent into the mountains. At the summit of Berthoud Pass were the chairlifts that were the gateway

into my later home of Grand County. Years later, after moving to Grand County, I learned of many other long-idle ski areas that dotted the landscape throughout the county. Most notable among them were Ski Idlewild and several hills surrounding the town of Hot Sulphur Springs. Idlewild offered a low-cost, family-friendly alternative to visitors than Winter Park. Most remarkable of all, though, is the ski history that surrounds Hot Sulphur Springs, where Colorado's ski industry began in 1911. Until the late 1960s, four different ski areas adorned its hills. Prior to the 1940s, the annual Hot Sulphur Springs Winter Sports Carnival was a mecca for skiing in the West. Today, none of the ski areas of Hot Sulphur Springs remain, though the town still has the feel of an old-time ski town, instilled by its citizens. As the director of the local history museum, the Grand County Pioneer Village Museum, I make it my mission to remind visitors that this is "where it all began" as I point out the remains of the old rope tow on the hillside behind the museum.

This book is an homage to the memories of all those long-lost ski areas that dotted the Colorado that I grew up in. It harkens back to a simpler era of skiing in the West, before the mega resorts of today rose to dominate the sport. As you read it, hopefully you will be intrigued enough not just to imagine what these lost ski areas looked like but also to actually seek them out. Maybe you will be tempted to hike up and slide the formerly lift-served slopes of Berthoud Pass and Maggie's Hill, like many others have.

B. Tim Nicklas
Museum Director, Grand County Historical Association
Author of *Winter Park: 75 Years of Imagining More*

Acknowledgements

Thank you to everyone—small-town historians and museum volunteers, U.S. Forest Service folks, antique shop owners, friends and acquaintances, authors and writers, filmmakers and lost ski area fans— for sharing your knowledge, memories, resources and photos so we could write this book. Special thanks go to Tim Nicklas, Bill Fetcher and Brad Chamberlin. Again, thank you all very much.

Introduction

*In the past we have taken pride in the crack shot, the champion rider, the roper,
and the all around horseman; but now we are developing another kind of athlete,
the boy on skis.*[1]
—Middle Park Times, *1916*

This book is meant to be your lighthearted ski tour of the lost ski areas of
Colorado. Hopefully, it will be like skiing with the trail broken ahead of
you or slopes well groomed. Enjoy!

These ski areas developed many boys and girls and men and women, in
skiing. At the same time, they gave birth to an industry that has benefited
Colorado beyond what anyone could have imagined back in the day. What
a positive economic impact skiing has had in the state!

The large and small areas that sprang up over the years gave joy to the
young and the young at heart. For a variety of reasons, they were lost—
over 140 of them. The history of some is settled and well documented.
For others, it's still sketchy, being discovered and written, and some
forgotten ones are just being remembered. In a few cases, we were just
not able to find enough information about a ski area to write about it or
to reliably locate it. We make mention of them so that others might be
inspired to document that history. Excuse us if our best guesses on some
miss the mark.

The areas varied. Folks created single hills on ranches, runs at the edges
of towns and formal resorts with many runs and lifts. There were tiny mom-
and-pop outfits, as well as areas with many investors. We hope in this book

Kids ski at Berthoud. *Courtesy U.S. Forest Service.*

to give you our best understanding of these areas, how they got there and why they went away.

This is the first of two books on the lost ski areas. It's about those in Colorado's northern Rocky Mountains and along its Front Range. The second book focuses on lost areas in the state's southern and central mountains and on the western plateaus.

At the beginning of each chapter, you'll stand at the top of the run (the chapter) and get a look at the terrain. Next, you'll drop in and ski the runs one at a time, reading about the discrete history and the unique people of each area. Endnotes will direct you to experts who can give you more detailed information on aspects of the lost ski areas and on ski history.

Unless we specifically indicate in one of the ski area descriptions that an old ski area is on public land or that public access is permitted, assume that the lost ski area is on private property. Even for some of the areas on national forest land, the base area was on private land. Therefore, you must obtain permission from the landowner before hiking or skiing those

areas. In many cases, the answer is likely to be no. Most of the areas, however, are visible from a nearby road. And using the GPS coordinates that we provide, you can always pay a virtual visit online. Neither of the books will tell you how to ski these places now; a few books already do that nicely. We refer you to them.

The books will give a general location for each area and then, when possible, give you a more specific location with longitude and latitude (GPS coordinates) so you can visit them online or even in person. The GPS coordinates are listed in degrees, minutes and seconds as they are indicated in Google Earth but can easily be converted to other forms using programs available online or on phone apps.

The locations we have provided generally coincide with a point near the base of the ski area or at some other point where we could identify a run or lift line from old aerial photographs or maps. The GPS coordinates are designed to help you find the lost ski area on a map or Google Earth or to navigate there. We have not provided detailed driving directions, as those can end up being both complex and confusing, and they are subject to change with development or road improvements. By giving the GPS coordinates, we give a very precise location for a point at the ski area, but leave some of the adventure up to you.

Even in Colorado, where the trees can be slow to grow, enough time has elapsed that some of the old ski areas have completely grown in, with only a subtle difference in tree heights or a linear stand of aspen to indicate where skiers once descended with abandon. For a few of the areas, we were not able to identify a specific location because the old descriptions were vague or the evidence has been obliterated by time or development.

The two lost ski area books are organized by county. There are sixty-four counties in Colorado. Roughly half of them had lost ski areas. The counties are placed as closely as possible in the book according to when skiing started in them to give the reader a sense of how skiing developed in Colorado chronologically. Within the listing by county, the areas are listed directionally as seemed logical for that county; sometimes, they will be listed north to south or east to west or vice versa. Or, they will be listed in the order that they came to be in the county.

Let's take a minute and get an overview of how snow piles up in Colorado and why and how skiing came to the state. This requires that we look at the geography that makes it a ski state.

GEOGRAPHY MADE FOR SKIING, A PLACE FOR SNOW

Colorado's got it. The Rocky Mountains occupy the central and west central portions of the state. This lofty backbone of the North American continent boasts numerous peaks that reach to more than fourteen thousand feet in elevation and is the source of four major rivers: the Colorado, the Rio Grande, the Arkansas and the Platte. These great rivers arise in Colorado due to topography, and their headwaters are sustained by snowmelt.

The great plains occupy about two-fifths of eastern Colorado and rise gently from east to west to the foot of the Rocky Mountains. Although the plains are too dry and windblown in winter to sustain a snowpack, they are on occasion subjected to great blizzards, which pile snow high in drifts along gullies, roads and fence lines. These drifts can last into the spring. And with a little bit of topography, and a whole lot of assistance from man to help pile the snow or make it, there were actually two lost ski areas located on the plains.

The Rocky Mountains cover about two-fifths of the central and west central portions of Colorado and, as might be expected, contain the majority of both active and lost ski areas in the state. The Colorado Rockies are composed of several (primarily north–south trending) ranges interrupted by broad open basins or "parks." The mountain ranges and parks are the result of complex folding and faulting, which occurred as the entire region uplifted. The combination of elevation and topography create great variations in snowfall and innumerable possibilities for the development of ski areas large and small.

The farthest west portion of Colorado is part of the Colorado Plateaus and includes broad valleys, canyons and mostly flat-lying plateaus. Many of the plateau areas reach elevations of eight to eleven thousand feet and receive great amounts of snow, even as the lower valleys and canyons remain snow free throughout much of the winter. Several lost ski areas are located on the slopes of these plateaus.

In general, snowfall in Colorado is greatest to the west of the Continental Divide, which bisects the state from north to south. Because the majority of storms move from west to east across the state, snow falls as the storms ascend each successive mountain range and plateau, and there is less moisture left after the air moves over the Divide and descends onto the eastern plains. On occasion, however, usually in the spring, the storm circulation brings moisture up from the Gulf of Mexico and pushes it back up against the mountains from the east, dumping great amounts of

snow in the foothills and mountains to the east of the Continental Divide. Many of Colorado's record single storm snowfalls have occurred during these "up slope" storms.

Snowfall is also generally greater with elevation due to the colder temperatures at higher altitudes and the mountain barriers that wring snow from the clouds. The colder temperatures at higher elevations also sustain the snow for longer periods, as do north-facing slopes and shaded forest areas. Almost all areas in Colorado located above nine thousand feet will receive in excess of one hundred inches (eight feet) of snow per season (on average) and have temperatures that can sustain a snowpack on north-facing slopes through the winter. Most of the active ski areas in the state have average snowfall in excess of two hundred inches (seventeen feet) per year and have base areas between eight and ten thousand feet in elevation. The highest snowfall in the state occurs in two areas: portions of the San Juan mountains (including Wolf Creek Pass, which gets storms from both the west and the southwest) and the Park Range to north and east of Steamboat Springs, which forms a barrier at the end of the long Yampa River Valley and gets both storms from the west and storms that move south out of Wyoming. The higher mountains and passes in each of these areas receive in excess of four hundred inches (thirty-three feet) of snow in an average year. Many other high mountain areas and plateaus, particularly west of the Continental Divide, receive from two hundred to more than three hundred inches (twenty-five feet) or more per year.

Most of the lost ski areas are found on north- or east-facing slopes, which have shade and cooler afternoon temperatures. Colorado's abundant sunshine quickly melts the snow on south- and west-facing slopes, even on some high mountain areas. Prevailing winds from the west also pile snow on east-facing slopes below ridges, and in fact, most of Colorado's few remaining glaciers can be found in those locations. However, in some of the snowiest areas of the state, and on some of the higher mountain passes, early ski areas were built wherever it was most convenient, including on south-facing slopes that were already free of trees or close to town.

In the northern tier counties of Routt, Jackson and Grand and some of the higher mountain counties, such as Summit, Lake and Gunnison, snow lies like a blanket for most of the winter, even on the exposed meadows and parks at lower elevations. Lack of snow was rarely an issue in these areas (although too much snow sometimes was). In other parts of the state,

Don Lawrie and Mary Sorenson ski on Pikes Peak in 1949. *Photo courtesy Don Sanborn.*

the snow builds deep in the higher mountains and valleys, but a snowpack may not be present at the lower elevations. East of the Continental Divide, snow can be more variable, and in some winters, the lower foothills (or plains) may get little snow while, in the higher mountains, the storms may be infrequent and the winds all too frequent, moving the snow to places away from the ski slope.

In the end, some of the ski areas were lost due to a lack of reliable snow, particularly some located along the Front Range, around the drier mountain parks and in the southeastern mountains. A few of these areas stayed open longer by developing snowmaking and some by snow hauling (literally moving snow from shaded or higher-elevation areas by snow cat, wagon, sleigh, truck, tractor or shovel and placing it on the lower slopes of a ski run). This was particularly true for many of the early jumping hills, which required a long runout onto an exposed meadow (or town street). As roads improved and newer ski areas developed in the higher mountain areas, people were drawn to the larger areas with more reliable snow. And after the horrible snow-free winter of 1977–78, even the big ski areas resorted to the type of snowmaking we now take for granted in order to sustain a reliable ski season and to stay in business.

Oh, and we'd like to mention one other thing important to skiing in Colorado, both past and present. The high elevations, the long distance from the oceans and the resulting dry air create something special. We call it *powder*. Colorado's got it, and most other states don't.

DRAWN BY A MAGNETIC FORCE

It seems that people with ski culture couldn't stay away from Colorado.

Two waves of immigrants came because they'd heard about the potential for skiing, one following the other decades later. They came by way of the East Coast of the United States and the Great Lakes region. First came the Scandinavians in the nineteenth century. These were humble tradesmen, and they used skis to get around and for fun; many found work as lumberjacks, cutting timber where it was found and skiing back to their camps. They brought their Norwegian snowshoes, later referred to as skis, and the Nordic disciplines of cross-country skiing and ski jumping.

Skiing had been common in Sweden, Norway and Finland for centuries. In fact, the first people to use skis in the world are thought to have lived in those countries, Russia, and the Altay Mountains of China. "Historians are divided on where skiing was born. Some argue that it arose in Scandinavia and northwest Russia though others point to the Altay region."[2]

The earliest of the skis they made looked more like snowboards; they were shorter and wider. One of the oldest skis found dated to 6000 B.C., as reported by *National Geographic*, and was found in Vis, Russia. It bent up at both tips and had a carved elk head on one end, which may have worked as a brake. A ski dating to 3200 B.C. from Kalvtrask, Sweden, looked like a long snowboard. It was used with a pole that had a scoop on one end, which may have been used to dig in snow and to club prey. The first "Norwegian snowshoes" were of uneven lengths with one very long and one shorter with a skin attached to it to aid in climbing. They are dated about A.D. 1600. Altay skis were also very long and had skins laced to them for traction. Some believe that these may date to 8000 B.C., but others dispute that claim. Norwegians created a shaped telemark ski a couple hundred years later. All were used with a single long pole.[3]

In the late nineteenth and early twentieth centuries, there was an economic downturn in the Scandinavian countries, so many young men emigrated from there to America. They immigrated to Colorado. The immigrants taught young people and others how to ski. They showed them how to make

Children show off their "Norwegian snowshoes." *Subject File Collection, Scan #10040190, History Colorado, Denver, Colorado.*

long, wooden Norwegian snowshoes of equal lengths. Not only did they pass on the sport, but they also set a pattern of the expert teaching the beginner and the elder mentoring the younger.

One who benefited was a schoolgirl in Grand County named Harriet Proctor Boyle, for whom Judge Wescott made a pair of Norwegian snowshoes over several weeks. She said this made her very proud because she was the only girl to own any. Another was a ten-year-old boy from a ranching family named Horace Button. Still another was a ski champion named Barney McLean, and another was Gordy Wren, and so on.

Skiing developed along parallel tracks in different parts of the state roughly in the same way; folks used skis first for utilitarian purposes—to get around, do chores, deliver mail—and later used them for enjoyment whether in the context of clubs, winter carnivals, competitions or tournaments.

A famous character in Summit County was Reverend John L. Dyer, commonly known as Father Dyer. He was from a family in the Midwest that owned sawmills, and he had been a "prospector in the lead-mines" before being called to Colorado. Though he was not an expert when he made his snowshoes, he became adept with them over the course of twenty-nine years. In the 1860s, he skied over the thirteen-thousand-foot Mosquito Pass several times a week to minister to people and to carry the mail to mining camps in all kinds of weather.

In Pitkin and Gunnison counties, the folks were using skis in the 1800s, too, sometimes for fun. "Crested Butte had a ski club in 1886, and it competed against a Gunnison club…Pictures from that time also show a Mount Sneffels Snowshoe Club at Ouray, which combined the fun with wining and dining."[4]

In the early 1900s, the passion for skiing was nurtured in the people's winter carnivals, competitions and clubs, which they created in the mountain towns and mountain parks across the state and on the hills near Denver. At first, it was all Nordic skiing, ski jumping and skijoring; it wasn't until the 1930s that Alpine skiing made its way west.

Alpine skiing was invented in Arlberg, Austria. This new method to negotiate the steeper terrain of the Alps came to America with the instructors who were trained there. They immigrated to the United States for economic opportunity. Like the Scandinavians, they came to the East Coast first and then came west. Unlike them, they made their living off skiing by teaching it, working for ski manufacturers and more. What they brought with them was a type of skiing for the elites and the trendsetters, the young and cool. Ironically, real estate development was a big part of this stream of skiing, too, and entrepreneurs played a big part in its success. "Downhill skiing

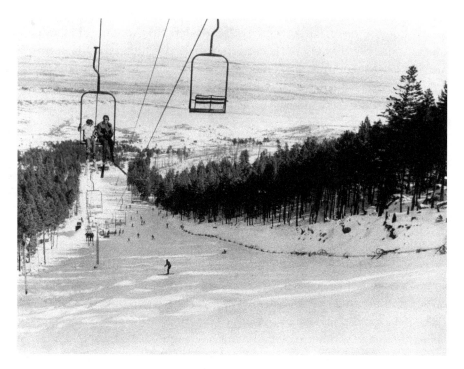

Skiers saw the plains from the runs at Ski Broadmoor. *Courtesy Broadmoor Hotel Archives.*

spread from Denver to surrounding ski clubs and more isolated mountains throughout the state. Although each group adopted the trappings of resort culture to differing degrees, they all responded to the influence of European experts," writes Professor Annie Gilbert Coleman.[5]

The *Daily Journal* in Telluride, San Miguel County, reported on a visit by champion ski jumper Lars Haugen in 1923. "Mr. Haugen was a visitor in Telluride on Saturday and is enthusiastic about skiing conditions in this section. He is a booster for skiing and believes that Telluride should have a real live active ski club that might in the course of a year or two promote a ski tournament which would attract as much attention as the now famous Steamboat Springs tournament which is held each year."[6]

A visitor from Switzerland who set up ski classes, Mr. Tschudin, wrote an editorial in the *Estes Park Trail* on January 25, 1924: "Colorado, and especially Estes–Rocky Mountain National Park, has a big chance to become the same sort of winter resort we have in Switzerland."[7]

With this kind of encouragement, residents of the different communities created ski hills, areas and resorts where everyone could learn and practice

skiing and enjoy other winter activities. These ski venues would thrive for a while and then shut down for various reasons. This continued through the twentieth century.

Bill Fetcher of Steamboat Springs, acknowledged expert on the lost areas (whom we thank for all his help—especially on the Grand County and Routt County hills), offers the following definitions, though the terms are somewhat interchangeable:

> *A ski hill operated primarily on weekends or for special events and holidays. It may or may not have had a rope tow. A ski area will have at least two lifts, a main lift and a beginner's lift, plus a base lodge or warming hut. Close by would be facilities for meals, lodging and sporting goods shops for equipment rentals and purchases. A ski resort will have separate base area lodging; condominiums come to mind. A resort functions year round, offering golf, tennis, hiking, mountain biking, alpine slide—the list goes on. A summer music festival is a sure way to put your resort on the map. A resort may or may not have a gondola, but the addition of one is a major step up from ski area status. On-mountain dining and other activities can now be offered.*

Why did all the areas shut down? According to Fetcher there were a number of reasons, including the following:

1. Competition from larger areas, particularly if nearby, which offered more up-to-date facilities and more challenging terrain.
2. Loss of customer base and volunteer help; children for whom a rope tow hill provided entry-level skiing would grow up, graduate and leave town to find jobs and ski elsewhere, and the consolidation of many small, rural school districts, beginning in the late 1950s, would fuel this process.
3. Deteriorating equipment; replacing a rope tow's worn, rotting hemp rope is an expensive proposition for a small community considering the loss of customers (See Number 2 above).
4. Inconsistent snowfall—in other words, "A ski area generates three months of income followed by nine months of bills," and lack of snow would doom several Front Range ski areas.
5. Insurance and regulatory requirements. Through the 1950s injuries involving ski lifts were accepted as one of the risks accompanying the sport, but as the country entered the "litigious '60s," with lawsuits filed for the most frivolous reasons, ski areas would be obliged to carry insurance and the

Colorado Passenger Tramway Safety Board would require lift attendants, proper signage ("Keep Ski Tips Up," "Unload Here") and regular lift inspections and tests. "It's easy to overlook the fact that a ski lift is a form of public transportation, just like aircraft, ships, buses and trains. They've had to become strictly regulated."
6. Financial difficulties, which would bring on further closures; the need for insurance, hiring additional help, plus trying to meet increasing skier expectations would lead to them.[8]

THE WHO AND WHAT

In early Colorado skiing, the people who created the areas were the working folks of communities, including loggers, ranchers, tradesmen and businesspeople. More than a few were real estate developers, even from the beginning. Often one or a few people stepped up as leaders. Virtually none of them was wealthy, but some of their supporters were. Communities developed ski hills and areas for their young people to give them something to do and to help the economies of their towns. Everybody pitched in and made the areas happen, at least for a while. It was a lot of work, though, and they couldn't always sustain the effort for long.

Into the midst of these Colorado people came a few remarkable folks, Scandinavians mostly, who were crazy about skiing. They brought the flame that got the fire going. Some of these people are in the Colorado Ski and Snowboard Hall of Fame, and rightly so. But the not-so-common everyday folk are not: the judge who made a pair of skis for a little girl, the rancher who lent his tractor to power a rope tow, the other rancher who lent his horses to pull a sleigh, the mechanic who kept the tow going, the mayor on the plains who created an area for the kids, the businessman who gave money so a warming hut could be renovated, the woman who ran a kitchen that fed thousands during winter carnivals, the innkeeper who opened his summer resort in the winter, the railroad workers who brought people up to the high country on the trains, the teacher who took her class out onto the hill at lunch time and more—many more. Both private citizens and government workers contributed what they could: old buildings for warming huts, trophies for competitions or equipment for youngsters.

These people were ingenious about getting themselves up the hills and getting other people up, too; sometimes, especially at first, they walked or

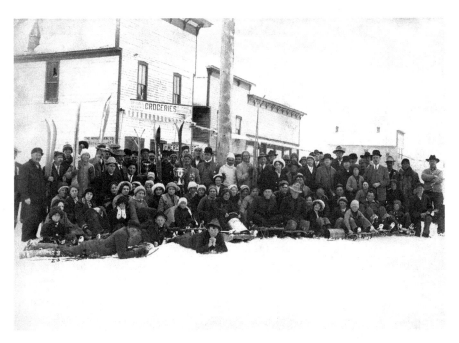

Participants in the first winter carnival west of the Mississippi gather in Hot Sulphur Springs, 1911. *Grand County Historical Association, Hot Sulphur Springs, Colorado.*

skied up or had horses pull them up in sleighs. They rode up in buses or trucks or cars. They created tows from what they had at hand or what they could borrow, barter for or lease from their neighbors. Or they used what some would donate to the cause—rope for tows, gas or electricity and the engines that used them.

As equipment got beyond what these folks could create themselves, and as it wore out, the people could not keep up, and often the areas closed. Children went to ski at the big areas, but the small areas with their humble tows and facilities had launched both young people and a skiing industry, which would thrive and make the hometown folks proud.

At the big areas, equipment was supplied by companies, such as Poma. You can view a timeline of when they supplied what to which areas at the current website of Leitner-Poma.[9]

Role of U.S. Land Management Agencies

Both the U.S. Forest Service (USFS) and the National Park Service (NPS) were involved with some of the lost ski areas because they were located on lands these organizations were responsible for managing. It's fair to say that sometimes their involvement was a help and sometimes it was a hindrance, at least to the private citizens who wanted to open and operate the areas. Every now and then while researching the lost ski areas books, we heard or read of the burdens of permitting, regulation and government agendas that individuals and communities faced. Sometimes they were defeated by them, and community areas were lost. In other instances, the idea, or the encouragement to develop a ski area, came from the management agency as part of a plan for recreation and economic utilization of the forests. Even the Bureau of Reclamation got involved; it donated lights to one area (Tabernash).

NPS oversaw the opening, running and closure of Hidden Valley (read more about that in Chapter 10). It was located in Rocky Mountain National Park.

USFS involvement started in the early days when recreational skiing started in Hot Sulphur Springs. It grew steadily over the years as skiing became a dominant winter activity in USFS Region 2, which includes the states of Colorado, Kansas, Nebraska, South Dakota and Wyoming. USFS personnel also worked with Civilian Conservation Corps (CCC) personnel on projects that benefited the ski industry. "In reality, some of the most notable CCC projects in Colorado were associated with that industry. As early as 1935, the Forest Service looked into developing Howelsen Hill…Once roads had been built and maintained to permit travel from Denver far enough toward the Divide to reach proper snow and ice conditions, ski trails were developed in the Arapaho National Forest at Berthoud Pass and at West Portal."[10] Ski areas sprang up like mushrooms, many of them on national forest land. So USFS personnel got busy managing them, and managing some of them was as easy as herding cats. "By 1938, cowboy boots were being traded in for downhill racing models on the North Park Ranger District of the Routt National Forest…However, many slopes and ski runs seemed so disorganized as to scare away the public."

You might think that accidents were among the biggest challenges, but that wasn't the case:

In reality, for the estimated 50,000 days of skiing during the 1938–1939 season, there were only forty-two accidents—all but two of the injured were

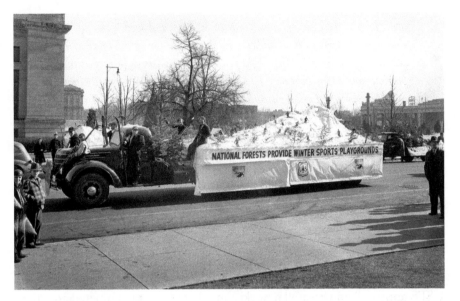

U.S. Forest Service personnel ride on their float in the parade for the opening of the Winter Park Ski Area, probably in Denver. *Courtesy U.S. Forest Service.*

novices. The problem was not disorderly crowds and uncontrolled skiing, but congestion. Encouraging cross-country skiing was thought to be one answer to the problem. Organizing a ski patrol to control the crowds and take care of the occasional injury was another solution. A third solution was increasing new downhill and slalom ski developments, such as at West Portal and Loveland Pass. [11]

World War II impacted the work of the land management agencies as well as everything else. The picture the USFS paints of the impact is instructive regarding what happened to all the lost ski areas in those years:

With the growth of winter sports, Region 2's national forests had also become practically yearlong playgrounds for the public…However, as one might expect, the war seriously cut into recreation utilization or delayed anticipated recreational developments on Region 2's forests, such as skiing. This reduction came as early as the winter of 1941–2, when use of the Berthoud Pass, Loveland Pass, and Winter Park ski areas declined ten percent, and continued downward in subsequent war years. In 1942, recreational use nationwide declined to sixty percent of the volume of the

previous year because of travel restrictions, gas and food rationing, and shortages of items such as rubber…In Region 2, during the 1942–1943 season, there were only thirty-eight percent of the skiers as there were in the previous winter. By February 1943, Region 2 skiing was generally limited to just the Winter Park ski area, because the surplus of gasoline of most of the skiers was nearly exhausted by then.[12]

After the war, winter sports became very popular and related USFS efforts were focused on creating more areas and better ski lifts and helping people to develop resorts and improve ski terrain. Regional forester John W. Spencer predicted then that Colorado would become the most important "winter playground" in the United States. "During the 1944–1945 season, Region 2 national forests had fourteen ski resorts."[13] Berthoud Pass was among the top three with thirty thousand skiers, and that number rose as organizers improved rope tows, installed new chairlifts (after applying for USFS approval) and created new ski runs. There was phenomenal growth in ski areas in the 1950s. USFS had to deal with all the bureaucratic processes it produced, including feasibility studies, permitting and political pressures. In the 1960s, more ski areas were created, including Indianhead, and each one opened to "fanfare." At the same time, environmental concerns rose about the impact of ski resorts on the public lands, and that continued as a factor that the USFS considered in its decisions, as did the NPS. These concerns caused some of the areas to close. The processes and management of USFS and NPS personnel continue today around winter recreation and ski areas.

1

Grand County

Recreational Skiing Takes a Leap

*Coasting on snowshoes has taken the place of dancing parties. Quite a number of
our ladies have become adept at the art...Our usually staid and sober citizens had
a frolicking streak last Saturday and amused themselves by coasting.*
—*Grand County resident, 1883*[14]

People in the county used Norwegian snowshoes, the long wooden skis
and a single pole, as early as the 1860s to do chores, visit neighbors,
deliver mail and more. In the 1880s, a Scandinavian county clerk in Grand
Lake used them to ski back and forth across Grand Lake between work
and home. M.C. Jahren is said to have introduced the townspeople to the
winter sport of having fun on skis and started a little friendly competition,
as reported in local newspapers. "The fact that the ladies of Teller are such
expert snowshoers has excited the envy of some of the Grand Lake belles."[15]

So the desire for a little winter recreation that would be needed for skiing
to take off in the county was there. However, recreational skiing didn't
really get going until 1911. The story of how it happened is the story of a
community and a venture that would revitalize the economy, connect it with
other communities in the state and make winter a lot more fun.

The tale of the lost ski areas of Colorado begins with the tale of a lost
ski town. In the early 1900s, Hot Sulphur Springs was a charming one
with a hot springs. During summer, people went there from the cities on
the plains—riding the train on the Moffat Road—to soak in the health-
giving waters and to enjoy the outdoors. Hardly anyone traveled there
in winter.

Then, an enterprising real estate developer by the name of John Peyer decided he would try to bring tourists to Hot Sulphur Springs year round. He called townspeople together in October 1911 to plan a winter carnival to fill up the hotels and the restaurants, according to B. Tim Nicklas, director of the Grand County Museum.[16] Peyer had a hill he wanted to promote, so he proposed that the winter carnival take place there. It was to feature ice-skating and sliding on toboggans and, incidentally, on Norwegian snowshoes, which were homemade.

Carl Howelsen and his buddy Angell Schmidt rode the train up to the Continental Divide at Rollins Pass where Corona was (elevation 11,680 feet). "They got off the train carrying their skis, 40-pound backpacks apiece, and rifles, and they skied all the way from Corona…and when they got here they set up the ski jump," said Nicklas.[17] They gave a demonstration of ski jumping that thrilled the spectators. So in Hot Sulphur Springs that December, the real estate developer with his business acumen met the immigrants with ski culture from the home country, and the Colorado ski industry was born.

Not only did ski jumping get a boost, but winter carnivals did as well—and along with competitions, they would really allow the passion for skiing to grow. This was the first one west of the Mississippi, and people loved it. The *Middle Park Times* on January 5, 1912, boasted: "A Carnival of Sports: Hot Sulphur Springs has broken all past records in a perfect panorama of innocent sports, good feeling and unbridled enthusiasm."[18] The Denver papers put on their headlines on the front page that Hot Sulphur Springs in Colorado was a winter sports mecca. Nicklas said, "And, so, it was so popular and enjoyed, the people who put it on said, well, let's do this again in six weeks, in February of 1912, and that will be the first *annual* winter carnival…Just six weeks later they put on the first annual winter carnival: Hot Sulphur Springs Annual Winter Sports Carnival."

This entailed a lot of work and cooperation in the community, especially because thousands of visitors would descend on the town for the carnival. The *Middle Park Times*, under Robert Palm, editor and publisher, reported on the effort February 2, 1912. The headline read, "Grand County's Winter Sports Carnival to be Held at Hot Sulphur Springs on Feb. 10th, 11th and 12th." A second headline read, "The Ladies of Hot Sulphur Springs Will Probably Give an Exhibition of Ski Jumping During the Big Carnival of Winter Sports."

The text gives insight into the community effort that was the carnival—and the number of people who were expected:

The Winter Sports Carnival, which at present is holding the undivided interest of everybody in this locality, promises to be a far greater success than was anticipated a week or two ago. The extensive preparations that have been made by the various committees for the entertainment of guests have been most satisfactorily completed. One of the most important things that the carnival association had to provide for was the suitable accommodation of those who will visit us on the 10th, 11th and 12th of this month. The Riverside Hotel has been leased for these days and will be operated by the Carnival Committee. All who secure accommodations will be assured of having warm, comfortable rooms. The committee has succeeded in inducing Mrs. H.F. Adams to take general charge of the dining room. This means that there will be served the best meals that were ever served in any Sulphur Springs Hotel. R. Pettingell has kindly consented to open the Grand Hotel and provide warm sleeping rooms. Those who are unable to secure rooms in either the Riverside or Grand Hotel may secure comfortable accommodations in private houses by notifying Mr. John Peyer, chairman of the Carnival Committee. The Riverside dining room will serve meals not only to those [who] have rooms in the hotel, but also to those who have rooms in other places. In solving the difficulty of accommodations the carnival association has satisfactorily solved the most difficult problem it had to face.

If there was anyone who lacked enthusiasm over the coming events, he has now laid aside his indifference and is working hard in hand with the others in making this carnival a success.[19]

Even with the amount of work required, the carnival went on every year, interrupted only by World War I, until nearly the start of World War II. "It really was one of the premier sporting events of the western United States. Hot Sulphur Springs and Steamboat Springs were *the* meccas of winter sports in Colorado all the way to 1940," Nicklas said. Carnivals over the years featured ski jumping, cross-country skiing and skijoring (pronounced ski-*your*-ing)—a sport in which a rider on a horse or a driver in a car pulls a skier holding onto a rope. At Hot Sulphur's winter carnival in 1913, skijoring was introduced in North America for the first time.

It took a lot of community effort to maintain the hills as well, and all sorts of people in the town were involved. When they were done with the work, they'd have a little fun apparently. And the folks at the *Middle Park Times* went with it, publishing a story in their January 30, 1914 edition with the headline "Judge Kennedy's Ride":

There are two rides in our nation's history which are sacredly popular. One is "Paul Revere's ride" and the other is "Washington's boat ride across the Delaware" on that memorable Christmas night. Thus far our nation's historians have not taken cognizance of a third ride. But it happened in this way. Last Sunday afternoon every able-bodied man in town was called into service to erect the tower on the summit of the hill at the head of the ski course. Most of the men had on skis and it was suggested that they coast down the hill. Among others who were on skis was Judge Kennedy of the county court. Charley Free and Ed Chatfield suggested that the Judge coast down the hill. "I'm game," said the Judge. Charley got the toes of the skis straight in the ski trail, while Chatty attended the heels. Everybody in town had at least one eye on that hill. Finally Charley shouted, "All aboard! Let 'er go!" Chatty yelled, "All ready, skiddo!" Zip—and the chief dignitary of the county court was on his way at a terrific and suffocating rate of speed. Dr. Harry A. Miller and Bob Throckmorton were time keepers and both these gentlemen declare on their honor that the exact speed at which the Judge was traveling was just a fraction over 99 miles an hour. But, oh! Such a ride. Behind those skis was a cloud of snow which looked like the funnel of a cyclone and which also resembled the tail end of those heavenly bodies, commonly known as meteors or comets. But those skis were on the high gear and so was the Judge. About the middle of the hill the time keepers were passed by the record-killing Judge, when Bob looked over toward Harry and murmured, "One of his skis is on fire." And Harry retorted in a low voice, "Lord help 'im, I can't." Another instant and the Judge had safely landed below. And Harry looked over at Bob and suggested that the Lord High Chief Justice of the County Court seemed to be safe, and Bob looked over to where Harry was standing and said in a voice scarcely audible, "Praise the Lord from whom all blessings flow."[20]

Another important pattern was set in those early years of skiing: the people who knew how to ski and loved skiing passed their knowledge and their enjoyment of skiing down to young people. They helped them to create and refine skis and they taught them how to ski jump. No doubt they had been taught this way in their home countries. But they brought it with them and spread the sport while helping the young people by giving them something fun and healthful to do during the long winters.

Many excellent skiers came up through the carnivals and the informal system of older skiers helping and mentoring the younger ones. They won

Horace Button heads to Denver for a competition. *Courtesy Grand County Historical Association, Hot Sulphur Springs, Colorado.*

many competitions in the county and across the state and even in the world as members of Olympic teams for the United States.

The good times were not to last for Hot Sulphur. World War I came along and the carnivals stopped, although they resumed after the war. Next, the Moffat Road Railroad built the Moffat Tunnel, which was completed in 1928.[21] At the west portal of the tunnel was a construction camp and school. A man named Graeme McGowan bought the construction camp and named it West Portal Resorts. That's when people first skied over there; they got off the train, stayed at the resort and skied on a trail that they cleared, the Mary Jane Trail. Nordic skiing and jumping were the only options for a while until Alpine skiing made its way west in the 1930s.

When World War II began the carnivals and competitions stopped again. They did not resume after the war. Also, Winter Park opened in 1940. That was really the end for Hot Sulphur, said Nicklas. No one was going to go past the Moffat Tunnel to Hot Sulphur at that time; it was easier to get off the train there, and they could ski at a bigger area. Plus, snowplows were clearing Berthoud Pass starting in 1933, and folks could drive to Winter Park. Still, the people of Hot Sulphur Springs loved skiing. They made their own hills and ran them as their town became forgotten by the outside world.

And the county had plenty of hills. Bill Fetcher gives an overview:

> *From Baker Mountain to Idlewild, Grand County can boast more abandoned ski hills than any other region in the state. Tracing the history and location of some of them is an ongoing process and some information is sketchy. Some hills are grown over or have been built upon. Rope tows seem to have taken on the character of Johnny Carson's family fruitcake: there was only one in existence, [and] it just got passed around from one hill to the next as customer bases shifted. A couple of hills only lasted a year or two; most all would be gone by the mid-'60s.*[22]

Drowsy Water Ranch was between Hot Sulphur and Granby. Several others graced the county and the towns of Tabernash, Grand Lake and Granby. West Portal Winter Sports Area was located in Grand County where the Moffat Tunnel emerged from James Peak. However, it was not really lost, just evolved into Winter Park. (We include it because of its historical significance.)

Runs for Berthoud Pass Ski Area were in Grand County, and it straddled Grand and Clear Creek Counties. (We have listed it in Clear Creek because skiers stopped atop the pass there.)

Hot Sulphur Springs Areas

The town of Hot Sulphur Springs alone boasted four ski areas: Bungalow Hill, Mount Bross, Maggie's Hill and Snow King Valley.

Bungalow Hill

Colorado recreational skiing took off from the first ski jump set up in Hot Sulphur Springs, on Bungalow Hill at the west end of town.

The *Middle Park Times* wrote of the famous first rides on that very jump in 1911: "Mr. A. Schmidt and Mr. Carl Howelson, professional ski riders, gave a brilliant exhibition of this admirable and hazardous sport on Bungalow Hill."[23]

Horace Button, a ten-year-old from a local ranching family, witnessed the first demonstration, went home, created skis from barrel staves and started jumping. He also saw the competition in 1912 and told Grand County historians that the Flying Norwegian, Howelsen, was surprised when Gunnar Dahle showed up for the competition and that he beat Howelsen in the cross-country and was second in jumping, beating Schmidt.[24]

The townspeople used the hill for jumping, and some fine ski jumpers trained there and took part in competitions there until the carnivals stopped for World War I. The jumpers were actually called riders in those days, and there were girl riders as well as boy riders. The experts were close by to mentor and teach them, and locals created skis for them. Bob Throckmorton made skis for the local kids, including a pair for Horace Button to replace the ones he'd made, and Horace Button was considered the most consistent rider of the hill and managed the jumping hills for many years. According to Idelia Baumgarten, who wrote a piece on Throckmorton for the *Middle Park Times*, "He sawed the hickory by hand, soaked it in the hot water pools at the Springs, then built a fire of shavings over a curved form to set the shape of the ski."[25]

The first ski course on Bungalow Hill was soon abandoned and a new course nearby was selected by a professional ski jumper. It was said that the new course was more precipitous and free from natural obstructions, and people thought it would help ski riders have higher and longer jumps with greater safety.

Today, a couple of cafés on the west end of town sit in front of the hill on the south side of Colorado Highway 40 near the west end of town (GPS

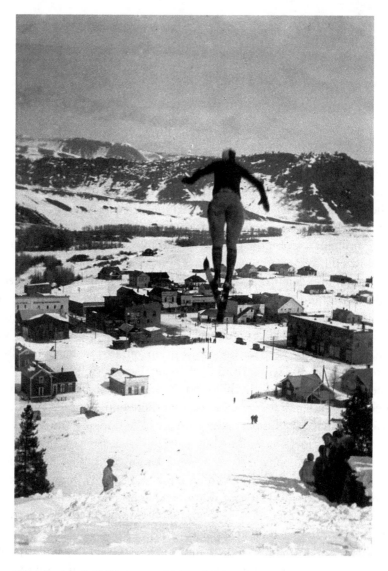

Winter carnival ski rider soars with Hot Sulphur Springs below. *Courtesy Grand County Historical Association, Hot Sulphur Springs, Colorado.*

coordinates: 40°4′19″N, 106°6′30″W). In 2014, Minnie's café sported a sign showing the people who used the hill for jumping.

Most of the tournaments were held here until 1937, and top ski jumpers competed on the hill, including Barney McLean, Olympic and hall-of-fame

skier. Nicklas said, "Barney McLean, many can argue, is the greatest skier ever to come out of Colorado. He has twelve national championships for both jumping and alpine, and he was captain of the 1948 Winter Olympic Ski Team."[26]

The town stopped using the hill because it became too dangerous. Said McLean, "At times it became quite a problem, for the lower end of the run came down across Highway 40; and as automobiles became more prevalent, you had to look out for the cars. It finally became necessary to get some of our friends to stand there and wave the cars down and stop them when we came off the hill."[27] (You can read more about McLean on the website of the Colorado Ski and Snowboard Hall of Fame.)

What was left of the ski jump on Bungalow Hill was torn down in 1983 because the townspeople didn't want anyone to get hurt on its remnants.

Mount Bross

Ski jumping moved to this mountain, which is north of Hot Sulphur Springs and across the Colorado River (GPS coordinates: 40°4'54"N 106°6'13"W), when a tournament was held here in the 1930s.

Horace Button talked about the jumping at Mount Bross, saying that the *Rocky Mountain News* sponsored a competition there in 1937. Also, he remembered that Alf Engen would jump in practice and then run up the hill and jump again, exclaiming how fun it was. He also talked about the downhill course he and Barney McLean set up and maintained, which he called the first real downhill course in Colorado.

Barney McLean spoke of the last race there, which was held in 1940:

The downhill race started near the top and went down the east side. With a lot of outstanding skiers coming, Horace and I had a problem. There were only the two of us to footpack that hill to get it into shape for the slalom. We got our heads together and decided if we could get some of his horses and some of the Thompson horses, we might be able to do a pretty good job. We took these horses and led them up an easy trail along the side of Mt. Bross, then drove them down the downhill course. We got our footpacking done that way. It really worked great. We ski packed it after that.[28]

37

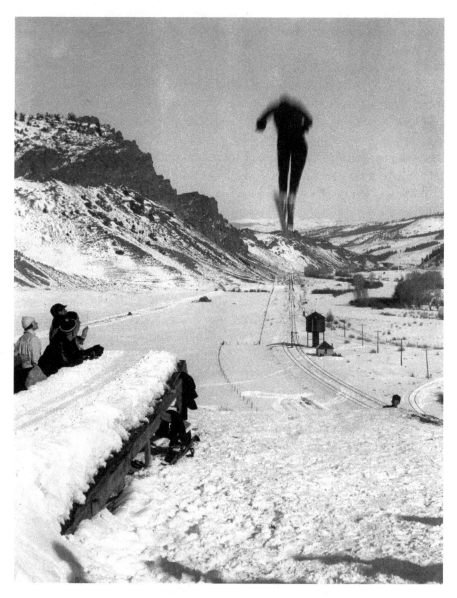

Riders enjoyed Mount Bross ski jump. *Courtesy Grand County Historical Association, Hot Sulphur Springs, Colorado.*

Maggie's Hill

Maggie's Hill was the area that ran the longest for Hot Sulphur Springs, lasting until the 1960s. It was located on the same ridge as the early jump at Bungalow Hill but was farther east and straight south of where the Grand County Museum sits along Colorado Highway 40 (GPS coordinates: 40°4'7"N, 106°6'15"W). The towers for the rope tow were still visible in 2014.

According to Bill Fetcher, "An announcement in the local paper [in] January 1949 stated the rope tow would be in operation every Saturday afternoon from 1 to 5 and all day Sunday. Admission was fifty cents. The hill appears to have been in use from the post WWII years through the 1950s… The tow's drive motor can be seen at the Grand County Museum."[29]

Maggie Armstrong skied on the hill. She attended the two-room elementary school in Parshall and remembers how one winter the regular teacher got sick. The substitute, who grew up in the east end of Grand County, was a new teacher named John Cress. He went on to ski Nordic combined for the U.S. team in the 1960 Squaw Valley Olympics. He convinced the school administrator to let the students in his class (fourth- through eighth-graders) out every Thursday to go over to Hot Sulphur Springs and ski. She said that he taught some of the boys to ski jump but never the girls and commented that Maggie's Hill was scary because it was really steep.[30]

Snow King Valley

After World War II, the people of Hot Sulphur Springs did not revive the winter carnivals that had been so important to their town. Instead, they decided to create a resort along the lines of Winter Park in the area southeast of the town about one and a half miles away (GPS coordinates: 40°3'15"N 106°5'2"W).

"With a grassroots fundraising of $6,000, an estimated $3,500 in donated labor, and assistance from the U.S. Forest Service, Snow King Valley opened in 1947 to great fanfare and expectations. The area consisted of three long runs served by a 1,500 foot rope tow. The base area had a warming hut, dining facilities, restrooms, and a large parking lot."[31]

Someone announced, "The winter sports area, known as Snow King Valley, will formally be opened to the public this Sunday, January 19th…This valley is located in the Arapaho National Forest about two miles southeast of

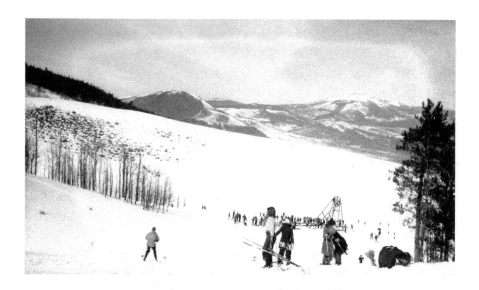

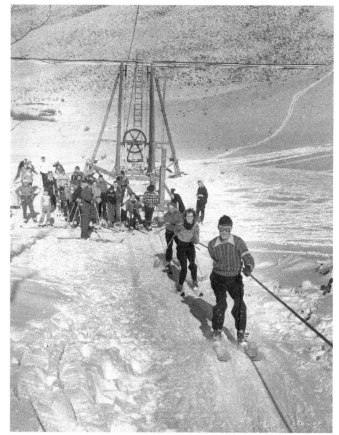

Above: Hot Sulphur Springs put their hopes in Snow King Valley. *Courtesy Grand County Historical Association, Hot Sulphur Springs, Colorado.*

Left Barney McLean rides the rope tow ahead of others at Snow King Valley. *Courtesy Grand County Historical Association, Hot Sulphur Springs, Colorado.*

Hot Sulphur Springs.—Improvements consist of a 1500-foot tow powered by a 'monster' fifty horsepower electric motor, practice slope, two intermediate trails, shelter house, toilets, parking areas, etc."[32]

Barney McLean came from Sun Valley for the opening and brought other members of the Olympic team: Gordy Wren, Barbara Kidder, Steve Knowlton and Dick Durrance. "Other ski celebrities there that day were Thor Groswold, Steve Bardley, and OA radio announcer Tor Torland."[33]

The opening was a great success, according to the *Middle Park Times* report on February 6, 1947. "Snow King Valley is a hit—over 800 visitors skied there Sunday."[34] It also reported that an old U.S. Forest Service barracks for the CCC had been moved to the site from Glenwood Springs.

However, Snow King Valley did not operate for long; people just didn't seem to want to go beyond Winter Park and Berthoud Pass for skiing. Bill Fetcher reported that Snow King Valley closed in 1952. "The rope tow would be passed on to Granby's Frosty Basin."[35]

MORE GRAND COUNTY AREAS

Grand Lake Grade School Ski Hill and Shadow Mountain Ski Hill

This mountain town with its deep natural lake had its own ski club—Grand Lake Winter Sports Club—that's still going. The town hosted its own tournaments during the 1930s, which included dances and parties. Everyone pitched in to help and to make sure visitors had a good time. Grand Lake created a hill right in town for the local children as part of their physical education program. Another ski hill and jump was located at the south edge of town at the base of Shadow Mountain. Later, they hoped to create a major ski area on Shadow Mountain. Unfortunately, those plans didn't come to fruition.

Betty Jo Woods wrote:

The hill by the school, actually a part of Lake Avenue, was converted into a ski slope [GPS coordinates: 40°15′7″N, 105°49′40″W]. A rope tow was installed on the east side and a jump was built on the west side. Students could then ski there during lunch, at recess, and even on week-ends. A rope tow was added to the facility on Shadow Mountain. The private property on which part of the hill was located was turned over to the county,

41

but the house continued to be used as a warming hut until the Bureau of Reclamation acquired the land during World War II. The ski hill was abandoned after efforts failed by the Grand Lake Winter Sports Club to obtain that property which would remain above the water line of Shadow Mountain Reservoir.[36]

Ms. Woods's recollections are confirmed by Bill Fetcher, who wrote

Grand Lake is somewhat removed from the other towns that had railroad passenger service, at least when it was offered...Despite this shortcoming, Grand Lake's residents were as enthusiastic about the sport as anywhere else...Lake Avenue dead-ends at what would be the base of the town's ski hill and conveniently enough the grade school (now a church) was close by. A rope tow was installed, about four hundred feet long with an electric motor drive at the top. The ski-jumping hill was down the west side, opposite the tow-served slope.[37]

About Shadow Mountain (GPS coordinates: 40°14′20″N, 105°49′40″W), Fetcher provided the following:

Skiing on Shadow Mountain began in 1931 when a ski jump was built. A rope tow was installed and a few runs cleared prior to World War II. Its history from then through the 1950s is sketchy; however, in 1961, there were plans to develop Shadow Mountain into a world-class ski area. There'd be restaurants, lodges, shops, chairlifts and a double-reversible aerial tramway (à la Jackson Hole) 2,850 feet long to the summit of Shadow Mountain at an elevation of 9,923 feet. All this would be built on the peninsula separating Shadow Mountain Lake and Grand Lake. It would have come online about when Vail, Steamboat and Crested Butte ski areas had their beginnings. When it was found that the ski area would encroach on Rocky Mountain National Park the proposal was turned down. Also the level of Shadow Mountain Lake was raised to increase its capacity. This action flooded land that would have been needed for the base area. (The outrun of the ski jump was flooded as well.) Except for the scar left by the ski jump, the former ski hill is heavily grown over. There is access to the site via two hiking trails, the East Shore Trail and the Shadow Mountain Fire Lookout Trail.[38]

Trail Mountain

Called Ski Trail Mountain by some, this small area was located between Granby and Grand Lake to the west, about 4.4 miles from U.S. Highway 43 on County Road 41 (GPS coordinates: 40°11′43″N, 105°57′9″W). Bill Fletcher noted in the same e-mail:

> *The other ski area in Granby was operated by George C. Carlson Jr., west of Highway 34 on Trail Mountain. This was opened in 1974 and lasted four or five years. Mr. Carlson said that they had a rope tow originally* [and] *then a Mitey Mite, like a T-bar. This was a family type of operation. Schoolchildren from Granby, kindergarten to sixth grade, were brought to the area to ski. They generally were open weekends and holidays.*[39]

ColoradoSkiHistory.com gives more details about the area: "It had two Poma platter lifts, built in 1968 with a length of 600; vertical of 80', with a capacity of 300 people per hour each; elevations: Base: 8,400 feet, Vertical Drop 450 feet; Operation dates: 1968–1971."[40] The area may have closed because snowmobiles became popular there.

Drowsy Water Ranch

This dude ranch, which first opened in the 1920s, is still operating, run by Ken and Randy Sue Fosha and family (www.drowsywater.com). You can go there for a stay in the summer and see where the early owners of the ranch set up a ski hill. The ranch and the hill are nestled in a valley between the towns of Granby and Hot Sulphur Springs; the specific location is about six miles west of Granby on U.S. Highway 40 and about one and a half miles north on County Road 219 (GPS coordinates: 40°6′42″N, 106°2′54″W).

The owner of the ranch in the 1930s and 1940s got the bright idea to offer skiing to guests. Author Penny Hamilton writes, "Just before World War II, the Glessners decided to open Ski Drowsy Water to expand guest operations year-round. As an amenity to the winter guests, a single sled boat tow pulled by a winch and cable lifted skiers to the top."[41]

Skiers ride the boat tow uphill at Drowsy Water Ranch. *Courtesy Grand County Historical Association, Hot Sulphur Springs, Colorado.*

Ken Fosha said that, after World War II, Dean Glessner built himself a ski lift and it ran for three or four winters, or something like that. Fosha also said that Oscar Enstrom was an instructor at Drowsy Water Ranch. The tow was "literally a set of stairs, built on a sled, and then they literally just winched it up, just by the end of a Model T, run the cable around it and winched it up the hill…Pops and Mom Glessner ran the dude ranch. Doc Jacques and Barbara ran the ranch after that. Then, their kids kind of grew up here."[42]

Interestingly, in his younger days, Fosha was assistant manager at Geneva Basin, from 1974 to 1976. He had been a ski instructor there from the early 1960s. And he worked as an engineer doing development up there. (Read more about what Fosha remembers about Geneva Basin in Chapter 15.)

In 2014, the ranch had thirty head of cattle and one hundred head of horses. The main horse trail up the hill across from the dude ranch lodge is the old ski trail.

Leland Jackson-Carmichael-Ouray Ranch Ski Hill (Granby, Colorado)

This was a lesser hill. Writes Jim Wier: "There were several small ski areas near Granby. Perhaps the first was north of town at the Leland Jackson ranch on the present Paul Carmichael place. There was a rope tow at that location."[43]

Fetcher commented that the hyphenated title reflects ownership changes over the years and that information on this hill is sketchy. It is known, however, that in 1952 its rope tow was passed on to Frosty Basin ski hill west of Granby. It was located on Grand County Road 620, 3.9 miles up U.S. 34 from U.S. 40 (approximate GPS coordinates: 40°7'12"N, 105°53'50"W). More research is needed.[44]

Frosty Basin Ski Area

Middle Park residents envisioned a ski club in 1952 at Granby and set to work. They built a small ski area with donations of cash and labor and named it Frosty Basin. We have not been able to determine the exact location of the ski hill, but it was located off County Road 57 to the west of Granby near the base of Mount Chauncey (approximate GPS coordinates:

40°5'48"N, 105°59'28"W). If you stand on main street and look west toward a long ridge, you are looking at the general area that contained Frosty Basin ski area. You can also get a view of the area from the visitor pullout along Highway 40 at Windy Gap Reservoir.

Jim Wier wrote, "Frosty Basin had a jumping hill, a warming house, and two rope tows."[45] One of the rope tows may have come from Leland-Jackson or Baker Mountain at Muddy Pass. The other came from Snow King Valley. "Oliver Kress said they had two electric motors donated: one, a fifteen and the other, a fifty [kilowatt]. The latter may also have come from now King, as they had a 'monster' fifty-[kilowatt] electric motor there. Cress said that they put up light[s] and the kids and people could ski two nights during the week. He added that there was a program for the elementary school kids one afternoon a week." The ski club had a ski swap and got skis to kids who couldn't afford them. It was quite a community effort, but it couldn't last; after about two years, the volunteers were tapped out, and the kids wanted to go to Winter Park to ski. So the area closed.

TABERNASH

The Tabernash hill was in the town by the same name (GPS coordinates: 39°59'29"N, 105°50'45"W). For ColoradoSkiHistory.com Fetcher wrote, "The Tabernash Ski Club and its accompanying rope tow hill were surprisingly long-lived considering the small size of the community and the lure of Winter Park just a few miles down the road. For 16 years it catered to local grade-schoolers and their parents and would host ski meets with neighboring towns."[46] The years of operation were 1945 to 1961. The Tabernash Ski Club leased the hill from Eldon E. (Buck) Thurston, and it reverted to him after it closed.

Jean Miller said that Joe Stithem, the first club president, was also the official tow operator and repairman. She tells a particularly colorful story about the area, which was published by the *Grand County Historical Association Journal*:

> *The initial rope tow, given by Winter Park Ski Area, was used just a year, for Lloyd Wilderman had to splice it constantly. Next year the club purchased a better rope. Lights came from the Bureau of Reclamation.*
>
> *Wilderman fetched car tire rims from Denver, to be rigged as idler wheels for returning the rope from top to the bottom of the hill. Young skiers flipped right off the tow when the old truck engine furnishing power was geared*

up. Later Russ Marr and Thurston located and installed an electric motor, while Virgil Young, who lived on Holcomb's ranch west of town, set the electric wire poles.

Using the best lumber they could rustle up, the townsfolk built a storage shed for the rope at the top of the hill and, for the bottom, a tightener block, which they constructed in Stithem's garage. Winter Park gave the club a used toboggan for first aid; the unlucky first occupant: Duane Farrar, with a broken leg. "Soapy" Wochner promoted the donation by the Forest Service of a building for a warming house. This was skidded from a ranger station up on Church's Park road to Tabernash with a team of Mr. Thurston's horses. The Club, in return, tore down and burned the remaining deserted Forest Service buildings. The Forest Service also donated outside johns to add to those obtained from the Tabernash school which had now been modernized. The latter had been constructed by the WPA.

The club operated the area three nights a week and on weekends. Non-club members were charged only the small fee of 50 cents...In 1951–52 the Tabernash school started a school ski program, letting out one afternoon a week...Up to 100 racers from schools at Grand Lake, Granby, Hot Sulphur, and Fraser flocked to regular ski meets. Local businesses and families donated trophies. Club members usually fixed chili and hot dogs on a coal and wood-burning range that somebody contributed, as well as offering cakes and pies. One time little Cindy Keenan raced in a county ski meet but her time didn't count because she was only four.[47]

Miller continued, saying that many of the young people who skied at Tabernash went on to excel as skiers, even participating in the Olympics, and others went on to work in the ski industry. She concluded, "From this small neighborhood project, then, grew lifetime vocations as well as skiing glory."

West Portal Winter Sports Area

In 1928, when construction on the Moffat Tunnel was completed, people would disembark where the train emerged from under James Peak. There was a construction camp and a school at the west portal of the tunnel, where the main base area for Winter Park Ski Area now stands. Graeme McGowan bought the construction camp and named it West Portal Resorts. People got

off the train and stayed at the resort and skied on a trail that they cleared, the Mary Jane Trail (at the Mary Jane portion of Winter Park Ski Area). The equipment was Nordic until Alpine skiing came west. Colorado Mountain Club (CMC) members got a preview of this ski area before the tunnel was officially open:

> One of the most interesting ski trips of the season was enjoyed by members the week-end of February 4 when as guests of the Moffat Tunnel Commission they visited the tunnel country. Driving to the East Portal it seemed the trip would prove a failure from the viewpoint of skiers but after making the ride through the Pioneer Bore to the West Portal they were greeted with enough snow to bury them. It was such a welcome sight with the moon-glow on the snow that several hours were spent enjoying the slopes in the camp. Put up in bunk houses, they were served a Tunnel breakfast after which even our best found it difficult in navigating. Ascent to Timberline was made up the old logging road. After lunch a speedy drop into camp and return through the Pioneer Bore to cars at the East Portal was made in record time.[48]

The club took many trips to West Portal, as did many others. It became very popular—and then it became Winter Park.

SPORTSLAND VALLEY

Bill Fetcher offers the following information on this short-lived area:

> Before there was downtown Winter Park, there was Hideaway Park, and before there was Beaver Village Ski Chalet (now the Beavers), there was Sportsland Valley. (The distinctive lodge, which still stands wasn't named after the dam-building rodent but for Preston and Hortense Beaver, who bought the property in 1948.) The lodge opened in 1940 along with a nearby ski hill served by a rope tow. Winter Park just up the road opened that year as well and had more to offer. The competition won out, and Sportsland Valley's hill shut down after one season. The hill is across the Fraser River and upstream from the Beavers. As might be guessed regarding a ski hill that was open for just one season, it's now heavily overgrown. A couple of tumbledown shacks mark the base area.

The Sportsland Valley ski slope is located to the east of the Beaver Village (approximate GPS coordinates: 39°54′43″N, 105°46′42″W). Travelers see this distinctive chalet after coming over Berthoud Pass and as they enter Winter Park. It was one of three great lodges that served skiers in the Winter Park area, before and after World War II. "During the year 1940 Sportsland Valley built a rope tow. 'Young Dick' Mulligan operated this for the one year it was open."[49] After the war, and when Winter Park opened, guests stayed at the lodge and went over there to ski.

IDLEWILD

Colorado Ski USA manual wrote that Ski Idlewild was located west of Winter Park, sixty-nine miles from Denver on U.S. Highway 40 and that Dwight Miller was the owner and operator.

Ski Idlewild features three open slopes and six trails all served by a double 2100' chair lift. The entire area is designed for the beginner and intermediate level skier. The beautiful Idlewild Run is the beginner's delight. From 300 to 400 feet in width, its gentle terrain makes learning to ski easy and fun. The steeper Arrowhead run is for the more advanced fan. The Yankee Doodle and Gandy Dancer will be enjoyed by the accomplished skier. Five connecting trails will make the day complete. The double chair-lift serves 600 skiers per hour with the latest in comfortable uphill transportation.[50]

The 1962–63 edition of the manual gave information on the Millers' inn and lodge at Idlewild:

Millers Idlewild Inn (Clifford and Gertrude Miller, Owners-Operators) Phone Fraser 726-2081. Located across the valley in Hideaway Park, the original Idlewild has been operated by the Millers for 16 seasons. Noted for its informal, relaxed atmosphere, the Inn features really great family style meals, rustic rooms and dormitories with carpet and baths. Extensively remodeled during the summer of 1962. Adding a new recreation room and photo darkroom. The fireplaces see friendly singers, square dancing, cards, movies…
Millers Idlewild Lodge (Dwight Miller), Phone Fraser 726-2341. Located at the base of Ski Idlewild, the Lodge is Colorado's most complete

ski resort. Spacious rooms, wall-to-wall carpeting, ceramic tiled tub shower baths, beautiful solid oak bedroom furnishings, and comfortable beds insure [sic] your perfect rest. The lounge is one of Colorado's most spectacular, with a high beamed ceiling and a 30-foot picture window looking across the winter landscape to Byers Peak...A friendly little skier's bar serves those who want some liquid warmth before dinner (or after, too).[51]

As of 2014, at least one of the main chair lifts was still in place, painted blue and easily visible at the edge of town behind the Winter Park Visitor Center (GPS coordinates 39°55′29″N, 105°46′48″W). With chairs still in place just as they were when it closed in March 1986, it seems as though you should just be able to press a button to start it up and begin skiing again. Although Idlewild is on private property, public access is possible along community hiking and mountain biking trails that traverse the area. Check at the visitors' center on the status and carefully read the trail signs.

Pease Hill

The community ski hill at Pease Gulch was located in a valley far from the railroad, far from the highway and, at times, a long ski from the post office. But for the local cowboys, cowgirls, railroaders and town folks, nowhere was too far to go for some winter fun after church. It was in the Williams Fork Valley, by road about fourteen miles south of Parshall.

The ski hill included a rope tow and one fairly short run, which was cut through the trees on a low ridge next to the Pease Ranch headquarters. Reed Taussig, whose family owned a nearby ranch and who was born during the time the ski hill operated, shared some of the history handed down from his grandfather and parents. He said that Pease Hill was started by local ranchers and ski enthusiasts in about 1949 and continued for a few years until the local ski club moved operations to Baker Mountain near Muddy Pass. Reed's grandfather Willard Taussig was one of those ski enthusiasts involved in developing both ski areas. Willard was quite familiar with skiing as a means to get around, and during one really bad winter, he had to ski all the way to Parshall to get the mail.

Reed Taussig's parents, Bill and Virginia, skied at Pease Hill shortly after they were married. Families would come to church wearing their ski clothes and then head off to ski after church let out.[52]

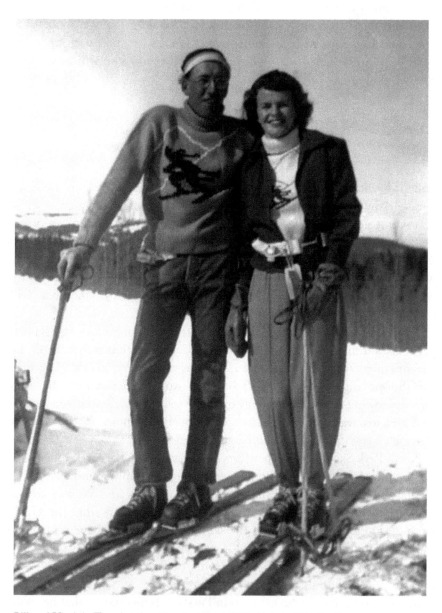

Bill and Virginia Taussig take a break at Pease Hill. *Photo by Ellen Crabb.*

You can still see evidence of the ski hill from the county road across from the Pease Ranch (GPS coordinates: 39°54′45″N, 106°6′50″W). It now shows up as a strip of young green lodgepole pines surrounded by beetle kill forest—a sort of reverse image of the old run, which was once cleared of timber.

BAKER MOUNTAIN

Baker Mountain, located near Muddy Pass, was a joint project of the North Park and the Kremmling Ski Clubs that had ample snow and a great ski hill and was a similar driving distance for both groups. The ski hill is located on Arapaho National Forest land and can be accessed by a USFS road that takes off from Highway 40 about one mile above Muddy Pass on the way to Rabbit Ears Pass. Because the area is on public land, you can still cross-country ski some of the runs and open meadows of the area (GPS coordinates: 40°22′27″N, 106°35′38″W).

There are some conflicting accounts of the operating dates and ski area particulars from various sources. Our best determination is that the ski hill was operated starting in late 1953 and was closed in 1957 or 1958. The USGS topographic map from 1956 shows two ski tow segments, but most reports indicate that there was only one rope tow. Electricity was run into the base area to a warming hut and to operate an electric motor for the rope tow, although a tractor may have initially powered the tow.

North Park Ski Club member Jerry Hampton (see Chapter 4) remembers cutting trees for the lift line and ski runs during the summer and fall of 1953 so that the area could open that winter. Joe McElroy and Willard Taussig (see Pease Hill section) were the main ski club members from the Grand County side involved in getting the ski area started. Everyone remembers Baker Mountain being blessed with great snow, and people would come from Steamboat Springs—including some of the Werner kids—and from the Parshall, Kremmling and Walden areas to ski.

Maggie Armstrong, who grew up in Parshall, remembered that her older sister started skiing at Pease Hill, but she learned at Baker Mountain. Their parents, who didn't ski, would drop them at the area for the day, and she was on her own to figure out how to ski. If you were a Middle Park kid, you pretty much had to ski, and you ended up knowing many great skiers, some of whom went on to the Olympics.

Bill Fetcher shared an e-mail he'd written to correct some inaccuracies that were being passed around:

Last summer I had a visit with Mary McElroy, daughter-in-law of Joe (Champagne Powder) McElroy. Her husband, Jack, had died a few years ago. As a boy he had worked for his father operating the Baker Mountain ski hill. I had a few questions for her and wanted to set the record straight on a few matters and avoid perpetuating inaccuracies. Here goes:

The story of the area having to close due [to] too much snow is only partially true, but it makes a better story. Actually, they were able to keep the road and area functioning much of the time. The area closed, not after three years, but in 1958, when Rabbit Ears Pass was closed at both ends for a few years for realignment. This effectively blocked access to the area. Also, volunteer help, such as Jack and other family and friends, had grown up and moved on, leaving Baker Mountain without a workforce. Such would be the fate of many small rope tow ski hills.[53]

KREMMLING SKI HILL

Sometime during the 1970s, the Town of Kremmling operated a ski hill a few miles south of town along the Trough Road (approximate GPS coordinates: 39°58'57"N, 106°26'17"W). The exact years of operation are not certain, but Bill Fetcher reported that his father, John Fetcher (1912–2009), designed a ski jump profile for the Kremmling Mustangs high school ski team in 1974. And although Bill was not certain whether the jump ever got built, ski jumping as a high school competitive sport was phased out in about 1978, giving some idea of the period when the hill may have been operated. The hill may have had a rope tow.[54]

2

𝒟enver County

One Hill on the West Side

The big snow did not breed many grouches—most folks were cheerful.
—Colorado Transcript, *1913*

In the early 1900s, a blizzard slammed Denver. The storm immobilized all its residents—except for one.

Carl Howelsen lived on Sherman Street and was working as a brick mason in the city at the time. To him, snow was gold, an opportunity for fun and fellowship. He went out and about, showing folks what could be done after a big snow. Some say he sparked a love affair with skiing for Denverites.

Howelsen's son Leif told the story and quoted *Municipal Facts* of January–February 1922:

> *"The big snow of December 4ᵗʰ, 1913, marked the real birth of winter sports in Denver, for immediately after that storm, when streetcars and traffic of all kinds were blocked in the business district of the city, Carl Howelsen, professional ski rider and winner of many ski contests, glided gracefully up and down the streets while a snowbound city looked on, marveled, and admired." One of the men who watched Dad gliding along shouted at him, "Hey! Can you teach me to do the same as you are doing?" Dad stopped and promised to do so.*[55]

Carl Howelsen taught George Cranmer to ski, and they became great friends. Then, they founded the Denver Ski Club, which became the Denver

Martha Springsteen (right), coauthor Caryn Boddie's grandmother, is almost lost in the drifts with her sisters Mary Louise (left) and Sylvia after the "Big Snow of 1913." Caryn Boddie collection.

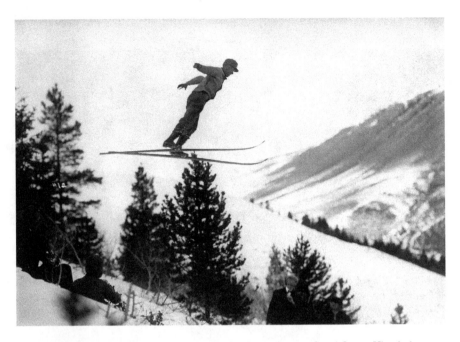

Carl Howelsen, the Flying Norwegian, shows his form. *Courtesy Grand County Historical Association, Hot Sulphur Springs, Colorado.*

Rocky Mountain Ski Club, according to Leif Howelsen. But first, there was something else to be done at Inspiration Point, a promontory overlooking Clear Creek.

"Howelsen, Bo Johnson, and Dr. M.R. Howard helped build a ski jump with materials at hand," wrote John McMillin in 1997. "Some painters loaned their ladders to form a base for the platform. Tournaments were held there for several years, but the view of snow-blanketed hills to the west, so prominent from the brink on Inspiration Point, eventually drew the skiers' ambitions westward."[56]

"The Denver Press Club sponsored an exhibition by The Flying Norseman,"[57] wrote author Annie Gilbert Coleman. Howelsen demonstrated ski jumping on January 19, 1914. Some twenty thousand people witnessed it and were suitably impressed because Howelsen rose thirty feet into the air.

This is how the sport was described in *Municipal Facts*:

Ski jumping is one of the most spectacular of sports, either winter or summer. The expert ski runner must exhibit a daring and skill that takes

away the breath of the spectator. Even the thought of a man leaping from a take-off at rifle-bullet speed and traveling through the air for more than two hundred feet before alighting is enough to send a chill down the back of one unfamiliar with this sport. The grace and balance displayed by the ski runner lends to the sport a fascination that fully justifies the place it holds in the minds of the Norwegian people.

An interesting feature of the sport is that one of the first rules the beginner must learn is how to fall properly. A good position is the first essential point. The beginner does not keep his skis parallel. Consequently the skis cross over one another or spread his legs apart until he loses his balance. In going down a steep hill and particularly in jumping, the best skiers sometimes fall. The veteran at the sport, therefore, advises the beginner to practice the fall as if this were the chief object of the sport. In going down hill the skier soon gains a momentum that makes him unsteady. This is the cue for the beginner, instead of spreading out his arms and legs to resist the fall to pull himself as nearly into a ball as possible and take the fall. As soon as he is down he should stretch out both arms and legs to prevent rolling and at the same time to get on his back and slide over the snow with his feet in the air to keep his skis from catching in the snow. This cannot always be done, but it is a good thing to get in the habit.

In traveling on the level the knees are kept bent and one foot is alternately shoved ahead of the other, taking advantage of the little glide that accompanies each step, without raising the ski from the ground. There is little fatigue in expert skiing, and it is not uncommon for a good ski runner to make eight miles an hour on a cross-country run in fairly level country. A hickory or bamboo pole, with a washer at one end to keep it from sinking into the snow, is sometimes used as an aid to maintain balance or gain momentum. A pole is never used in tournament contests, however.[58]

The newsletter was promoting a national ski tournament that would be held at Genesee Mountain Park, which was run by the City of Denver. The city played a role in it by making sure the roads there would be in good condition and providing police to manage traffic. Denver would also continue to play a large role by owning Winter Park Ski Area and sending ski trains there from Union Station.

Municipal Facts also stated that the city's first ski tournament was held at Inspiration Point in 1917.

You can go to Inspiration Point today. It's a Denver park just north of Interstate 70 and Sheridan Boulevard (GPS coordinates: 39°47′14″N, 105°3′38″W). Walk on the path to the west end of the park and see if you can imagine a time when people gathered there to watch the spectacle of ski jumping. It's also a great place to watch a sunset.

3

Routt County

Steamboat Winter Carnivals Get Rolling

I liked Denver, but once I commenced to travel on the Moffat road I thought this must be the country for me and my skis.
—Carl Howelsen, 1917

C arl Howelsen came to really belong to Steamboat Springs and that community to him, even though he started in Hot Sulphur Springs, affected skiers in Denver and traveled to many communities and tournaments across the state.

The railroad that had carried him so he could ski to Hot Sulphur with his friend Angell Schmidt also figured into how he came to Steamboat. One of the travelers on the train stopped to see him jump and then invited him to continue on the Moffat Road to Steamboat Springs, and he later went on to work and live there.

Howelsen's son, Leif Howelsen, told the story in a presentation at the Tread of Pioneers Museum in August 2003. It's worth getting it in his words:

> *On February 12, 1913, Marjorie Perry was traveling from Denver to Steamboat Springs on the Moffat Railroad. As usual, the train stopped for some time at Hot Sulphur Springs. Thus, a friend of Miss Perry rushed to the station to catch her. After a warm welcome, she told about the Winter Carnival that was going on. "It is so exciting," she said, "that you must get off the train and stay and see the ski-jumping exhibition tomorrow morning." Miss Perry did not need further urging. She had a flare for adventure and decided to spend the night. What she saw the next day she*

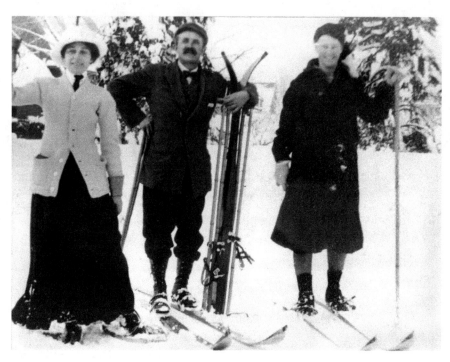

Marjorie Perry, Carl Howelsen and a friend share a moment in Steamboat circa 1915. *Provided courtesy of Tread of Pioneers Museum, Steamboat, Colorado.*

liked. She was so enthused that she persuaded Dad to come to Steamboat Springs and to demonstrate his talents there.

Miss Perry, a person of character and independence, was born to a well-to-do family with roots in mining and railroading. She shunned Denver High Society life and would rather follow her father on his hunting trips. She [was] to become the patronesse of the professional skiers when they came for the skiing events in Steamboat. She rejoiced in entertaining and caring for these men whenever they came from the East and Midwest to compete. It happened more than once that she picked up the competing skiers from the contests in Hot Sulphur Springs, taking them in David Moffat's private coach to be able to reach the Winter Sports Carnival in Steamboat Springs in time.

When Dad arrived in Steamboat Springs for the first time, he immediately knew in his heart that here was the place for him. The mountains, the open valley, the ranches and the people, everything appealed to him. On that very first trip, he stayed long enough to build a jumping course on the side of

the Woodchuck Hill where he demonstrated his jumping and cross-country skiing. The spectators who had gathered for the occasion were thrilled and wanted more.

In the fall he returned to Steamboat Springs and bought a ranch in Strawberry Park. It did not take [a] long time before the Steamboat Springs Winter Sports Club had been founded and for the town to hold a Winter Sports Carnival. The carnival of 1914 became a great success, and so it happened in Steamboat Springs as it did to Hot Sulphur Springs and Denver that the "White Sport" had come to stay and became the focus and high point of long winter months.

In the summer and fall of 1915, Dad raised hogs on his ranch, but he had also another enterprise up his sleeve. Bordering the town, a steep hill on the far side of the Yampa river had caught his imagination. Dad earmarked it for a new jumping hill. He convinced the townspeople about the need for the course and was given the permission to go ahead. Greatly helped by eager volunteers, by the time winter set in, the hill was ready to go.

In comparison to other ski jumping hills in the world, the new course in Steamboat Springs was a giant one, a challenge of daring and skill to the jumpers, indeed. The Club invited the best of the professional skiers of the Midwest to come and compete, and they turned up. When the brothers Lars and Anders Haugen from Minnesota and Ragnar Omtvedt from Chicago arrived in Steamboat Springs, they stared at the hill, and Lars said to Anders, "I would rather take poison than to jump here!" And Omtvedt told Dad that he was scared stiff when he for the first time had seen the hill.

The new course turned out to be a hit. As they little by little learned the right technique to master such a giant hill, they became excited about jumping on it since they had never jumped so far before...There was excitement in the air as the Carnival of 1916 approached. Everyone wondered if Ragnar Omtvedt would set a new record in jumping. A skier in Norway had beaten Omtvedt's standing record of 169 feet and scored a new record with 177 feet.

On Wednesday, February 23, 1916, the Pilot *splashed the news. "World's Ski Record Raised 15 feet 9 in. Ragnar Omtvedt, on Steamboat Springs course, the Fastest Ever Known, Jumps 192 feet 9 in. and Says That 200 Mark Will Be Reached Here at Next Carnival." Another headline on the front page ran: "Three Thousand Witness Record Breaking Flight. Greatest Crowd in County's History Cheers Champion To Greatest Effort."*

The record-breaking feat of Omtvedt made the name of Steamboat Springs known throughout the world and the town people loved it. In the carnival of 1917, Henry Hall set a new world record of 203 feet and again the news went out to the world. The Steamboat Springs course is now a house-hold word in the skiing world, and it played a great part in changing the style and technique of the art of ski jumping.[59]

Letters between Howelsen and Marjorie Perry were published in *Steamboat Magazine*. He wrote the following after the 1917 winter carnival while visiting Craig. Perhaps he was traveling for his work as a bricklayer. He also encouraged folks in the small communities to create their own ski hills and carnivals.

Dear Miss Perry: The skisport is getting more popular every winter, in the east and so in the west. And by hearing of this long jump, which can be made here in Steamboat, and far beyond any other places, we will have more people and better carnival every winter.

We have to have this jumping contest in order to attract people, although this is just a fraction of the skisport. In general, skisport is for everyone and will be enjoyed in years to come.

Sincerely yours,
Carl Howelsen[60]

Following Howelsen were other great skiers who did Steamboat proud, including Buddy Werner and Gordy Wren. Buddy was considered by many to be "America's first truly world class ski racer."[61] He was a resident of Steamboat who died trying to out ski an avalanche in the Alps in 1964.

Gordon Wren was inducted into the Colorado Sports Hall of Fame. "Steamboat Springs has produced more than its share of Olympic skiers, but the best of them all remains as Gordon 'Gordy' Wren, the do-it-all-guy of the 1948 Olympics in St. Moritz, Switzerland. He is one of the only American skiers ever to qualify for both Nordic and Alpine events. And his second in combined jumping and fifth in special jumping was the best-ever performance by an American ski jumper."[62] Gordon Wren is remembered for managing several ski areas and helping youngsters in the communities throughout Northwest Colorado, thus helping to establish skiing there.

AIRPORT HILL

The *Yampa Leader* reported on a visit to the town by the Flying Norwegian in 1916:

> *Carl Howelsen, the famous ski jumper, was in Yampa the first of the week and as a result of his splendid offer to come here and lay out a ski course, a movement was at once started to organize a Ski Club. Business men of Yampa have given assurances of financial support and a number of prizes have already been offered. Dr. Cole is starting the prize offers with a $5 ski outfit for boys and $10 ski outfit for young men. James Cole has charge of the membership list and has already secured a number of signers, who will take active part in this splendid winter sport.*[63]

The people in Yampa were excited to start their own ski club, and they created a ski hill. It was located in what is now the town of Yampa (GPS coordinates 40°9'5"N, 106°54'44"W).

Rita Herold, who grew up in a longtime ranching family in the county and volunteers with the local historical society, told the story of the hill. As Rita was talking with the authors, Paul Bonnifield, another resident of Yampa, happened along.[64]

The town cleared a course from a hill through the sagebrush toward the town below. The skiers would walk up and ski straight down. "There was an airport up on top in the 1930s, which is why it got the name Airport Hill," Herold explained.

In the years that followed, skiing was lost on the hill until Elwood Jordan, the pastor at the Congregational Church from 1938 to 1942, started a Boys Club for junior high and high school boys, she said. The club garnered enough interest in skiing that they started skiing again on the hill. She added, "I think what he was doing was giving the boys something to do, recreation-type opportunities. You know, if they're kept busy doing recreation, then they're not in trouble. I think that was his idea because he...enjoyed the physical activities himself."

Herold said, "Not only the kids in the Boys Club, but some of the older people, got reinterested in the ski hill, and they set up, at that time, a rope tow and went down kind of the same track. I was pretty little; I can't remember exactly. But it was kind of down the same track. And anybody that was interested then in doing it, they just left it set up, and as long as you brought some gas for the gasoline engine, you could start the tow and use it. That was

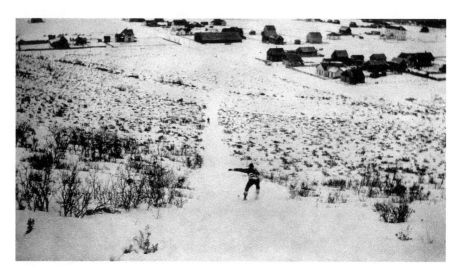

A skier slides from Airport Hill toward Yampa. *Courtesy Yampa-Egeria Historical Society.*

probably 1950 or thereabouts." Rita remembers because her older brother skied the hill.

Paul Bonnifield said he skied on it:

> *The school kids came up, and they had a rope tow that went up the hill. It was just a rope tow hill, just a local hill. In the late '40s/early '50s, there were a lot of people who wanted to become skiers, you see. Then, there was a guy that was a chemistry and science teacher at the high school…He had been on the ski team at CU and so he was a kind of ski enthusiast. At least one year they did have it operating that they could ski up and down. Eddie Farrington told me the reason they stopped doing it was because of the insurance, the cost of the insurance.*

Herold said, "Cary Tranton preferred skiing to riding a horse, and so he used the skis. This is according to my dad. That would be in the [1910s] and in the 1920s. He skied quite a bit and he was out of town."

Bonnifield talked about how skiing came to Routt County:

> *What you have then, and Howelsen was one of them, is there were the sawmill people more than the ranchers. They were the Swedes, that general term [meaning] Norwegian, Swedish, the Scandinavian people. And they were the ones that were the loggers. They were also the ones that did a lot*

to build the railroads, and they're the ones that did the skiing. The heritage of the skiing is predominately because of the loggers…and these were from the home country, and their culture was skiing. And Howelsen fit well within it.

Herold said, "Well, I hadn't thought about it, but that's why my dad would have skied."

"Sure," said Bonnifield, "And your granddad had a sawmill, you see, and Yampa was a logging town, you see. There [were] a lot of sawmills around when you go around Hot Sulphur and then Middle Park and on up Fraser, that area, all over there was Swedes. And one of the largest organizations in the state at the time, and they had a large organization here in Yampa, as well, was the IWW…International Woodsmen of the World…Most of them are gone now."[65]

CAPITOL HILL AND COWBOY PEAK

In the 1960s, the town of Oak Creek had a ski hill, which was run by the Lions Club. It was located off the east end of Highland Street in what was called the Town Pasture or Capitol Hill (approximate GPS coordinates: 40°16'18"N, 106°57'15"W). The hill was later moved to the Sweetland family property just north of town (GPS coordinates: 40°16'52"N, 106°57'26"W). Betty and Chuck Sweetland leased four to five acres to the city for the hill at one dollar per year for nearly ten years, and the Lions Club continued to operate it. Winter carnivals were held on the hill each winter. Then, the Lions Club disbanded, and the city took over the operation of the hill.

The city paid the rent, sometimes, and bought insurance for the operation and operated a six-hundred-foot rope tow.

Dean Cork wrote about what it was like to ski at Cowboy Peak.

The time was the late '60s through the '70s. The place was Oak Creek, Colorado, south of Steamboat Springs. The lift was a rope tow. The rope tow, originally on the south side of town and later moved to Cowboy Peak, was constructed by town employees and volunteers. The town of Oak Creek even added street lights so we could ski at night.

Skiing Cowboy Peak was a kid's dream. The peak had it all: powder, bumps, trees (if scrub oak counts, which it did to all us kids) and an ear-flattening 500

FAST TIMES
AT COWBOY PEAK

IN
OAK CREEK,
COLORADO

SATURDAY
MARCH
9th

1 P.M.
· SKI RACES

2 P.M.
· OBSTACLE
 COURSE
· OTHER EVENTS

10 A.M.
· CROSS COUNTR·
 TOURING

11 A.M.
· TUBE RACING
· KIDS SKIING

7TH

ANNUAL
WINTER
FESTIVAL

·ICE SCULPTURE JUDGED AT NOON

Flier advertises for Oak Creek Seventh-Annual Winter Festival. *Courtesy Oak Creek Historical Society.*

feet of vertical. Skiing the peak was simple. You just walked up, turned on the lift and went skiing. When it got dark, you turned on the lights.

The ski hill was the hot spot for kids after school. You could always tell if someone was skiing because of one squeaky rope pulley (which were

car rims) that could be heard clear across town. We all skied after school playing hide-n-seek and tag. We built big jumps to practice aerials. I turned my first helicopter on Cowboy Peak. We always skied till around ten at night. I could see my house from the lift and Mom would turn on the porch light when it was time to come home.

The skis were long and the lines were short and no one, large or small, ever bought a lift ticket to ski Cowboy Peak. Mom still leaves the porch light on for me when I come by for a visit and I still get a big perma-grin reminiscing about Cowboy Peak. Maybe I'll hike up and take a run on Cowboy Peak this winter. I'll probably run into a few old friends.[66]

Skiing on Cowboy Peak ended in 1985 for a reason all too common in the story of the lost areas: government officials clashed with members of the community. Uniquely, for Oak Creek, the conflict was all about a dog and five dollars.

Reporter Jack Kisling told the story in the *Denver Post* on March 13, 1985:

The standoff began a week ago when the Sweetland's female Bassett Hound, Casey, was nabbed by the dogcatcher while sitting on the steps of the city hall in this hamlet 25 miles south of Steamboat Springs… Casey ran afoul of the dogcatcher and was lolling forlornly in his truck when Betty Sweetland found her and paid the $20 fine on the spot. But she balked at paying $5 in court costs for the violation, and so did her husband Chuck.

Like Betty, Chuck Sweetland readily admitted Casey's guilt. "She's an independent dog." But he didn't want to pay the $5 court costs because "if you're guilty why go to court? Just pay your fine and go on about your business."

City officials insisted on the $5, even though they said the Sweetlands didn't have to appear in court. Police Chief Reggie Mayes said the fee is required on all leash-law cases, and there isn't any provision for waiving it.

So, the Sweetlands paid the $5. Then they told the city officials they would have to find some other site for the ski operations.[67]

Thus, Cowboy Peak was lost.

Emerald Mountain

Bill Fetcher told the authors about Emerald Mountain when we interviewed him at his place in Steamboat. He said, "It was rough-and-tumble skiing, and the ski lifts pretty much lived up to that too."[68]

In an e-mail to another lost area fan, Peter Bronski, he wrote:

Steamboat's "World's Longest Single-Span Ski Lift" (8,850 feet) was built in 1947 and opened in late January 1948...The lift was a vain attempt to compete with Aspen and Winter Park, at the time Colorado's two major ski resorts. Aspen had opened the World's Longest Chairlift, which was actually two lifts in tandem. Steamboat would one-up Aspen with one continuous lift. The two-carrier set-up, with a single-chair spaced between two T-bars, while unique, was only used for the opening 1948 and following 1948–1949 seasons. After that it was strictly a T-bar lift; the chairs were only used for summer sightseers, replacing the T-bars. There were two reloading stations along the line, one on the backside of Howelsen Hill where the Mile Run crosses, the other at Tower 18 just before the final steep pull up the face of Emerald Mountain. Assuming the two-carrier arrangement, you took whatever vacant carrier came along, be it an empty chair or T-bar. The Veteran's Memorial Run, cut before the lift was built, roughly followed the lift-line. The old lift-line is to skier's left of it and is nearly grown in at the top. From town, the lift-line is to the right of the power-line. Lift-served skiing on Emerald ended in 1954 after only six years. The steel tower and terminal sheaves caused undue wear and fatigue on the cable requiring its replacement every two years, an expensive proposition considering three miles of cable and the matter that the lift was never paid for. It was shortened to serve just Howelsen Hill in 1970 was replaced by the present Pomalift.[69]

Brad Chamberlin also wrote about Emerald Mountain on ColoradoSkiHistory.com with contributor Fetcher:

Emerald Mountain began operation during the 1947–48 ski season. The area contracted E.G. Constam to install the area's only means for uphill transportation. Constam is credited as being the inventor of the T-bar lift and during this era held the record for the longest installed lift at Camp Hale in Colorado. Prior to the construction of the Constam lift, Emerald Mountain also boasted a boat tow, and at least one rope tow.

Folks ride the boat tow at Emerald Mountain. *Provided courtesy of Tread of Pioneers Museum, Steamboat, Colorado.*

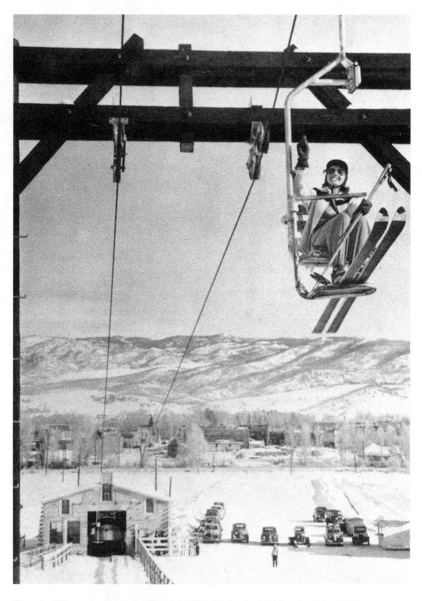

Dorothy Wegeman rides the Emerald Mountain chairlift in 1948. *Provided courtesy of Bill Fetcher and Tread of Pioneers Museum, Steamboat, Colorado.*

After a few years of operation, the Constam lift was shortened to the top of Howelsen Hill, where the current Poma terminal is located. During this time, the single chairs were also removed and the lift was just a T-bar. During the 1970's a lift malfunction caused [the] removal of the old Constam lift and it was later replaced by a Poma platter lift.[70]

Fetcher told the authors:

In the case of our Emerald Mountain ski lift, it wasn't so much changing technology but application of inappropriate technology in keeping with the builders' patents. In other words, that lift had steel tower sheaves instead of rubber lined in keeping with Ernest Constam's patents. It wore the cable, just the vibration fatigued the cable whereas the ski lifts and chairlifts in the 1940s did have tower sheaves with rubber linings. It started off as a single chair lift and T-bar combined for the first two seasons. Then, after that, it was strictly a T-bar during the winter months and then they put the chairs on for summer sightseeing. We also had a downhill course on Emerald Mountain...after the lift was moved, they still ran skiers up in jeeps or they'd run them up to where the quarry was and then they had to climb up.[71]

Clark Community Hill

Fetcher grew up on the ranch of his parents north of Steamboat and a short ways from the town of Clark. There they ran a community ski hill on a long, gentle slope behind the barn (GPS coordinates: 40°41′46″N, 106°56′34″W). Fetcher tells the story:

While of little historic value, the rope tow hill that served the ranching community of Clark, 20 miles north of Steamboat Springs, was perhaps typical of weekend rope tow hill operations.

In 1955 the rope tow on Steamboat's Howelsen Hill was relocated and rebuilt. Through a work-exchange agreement my father, John Fetcher, acquired the old rope, wheels and other parts. With volunteer help from neighbors the tow was installed on a hillside pasture on our ranch at Clark. It was driven by a tractor located at the top of the hill. Most ski lifts have their drive motors at the top, as it's more efficient to pull the load. In this instance it meant gasoline had to be hauled to the top, plus someone had to

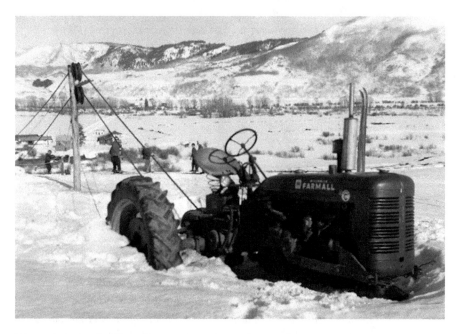

The rope tow at the Clark Community Hill was powered by the Farmall tractor. *Courtesy Bill Fetcher.*

climb the hill to start the tractor, often by vigorous cranking if the battery was dead, which was often the case. Length of the tow was about 500 feet, an average peak length for most rope tows as it was about all one's arms, hands and smoking mittens could stand.

The tow ran on weekends, usually with an average afternoon crowd of 30 to 40, mostly neighbor kids and their parents who had driven them over once their morning chores (feeding the livestock for most) and noon meal were finished. An admission was charged to offset such small expenses as fuel for the tractor: 25 cents a day or 20 cents for an afternoon.[72]

HOSPITAL HILL

Fetcher remembers this hill in Hayden (GPS coordinates: 40°29'39"N, 107°15'13"W). He wrote:

This appears to have been one of Gordy Wren's ventures. He takes credit for promoting skiing for youngsters by launching a number of small-town rope tow hills during the 1950s. I recall this hill sported a rope tow during the late '50s. It crossed an irrigation ditch, which was roofed over. The hill, also used for sliding, is to the east of Solandt Hospital approximately where Washington Avenue and Aspen and Pine Streets meet. Though the hill looks steep, bear in mind that several decades of overgrowth, erosion and construction have altered the hill's contour.[73]

HOLDERNESS RANCH

According to ColoradoSkiHistory.com, this hill with one rope tow (electric motor at the top) was located "southwest of Hayden just off Routt County Road 65 (Breeze Basin Road) past the elementary school"[74] (GPS coordinates: 40°29'14"N, 107°16'7"W). Jack Holderness built and ran it in the 1940s. *Steamboat Magazine* told the story in 2007:

The first came in 1947, when volunteers helped bridge the Walker and Shelton ditches and installed a tow at the Edison elementary school, now the site of the Redstone Motel. "I was going on nine and in the third grade— and that is probably the year I got my first pair of skis," remembers Jan Leslie. "During recess the school custodian, 'Colonel' Du Beau, operated the rope tow. More often than not, my mittens got caught in the rope and were carried to the top of the hill and one of the older kids would make sure I got them back." Olympian Gordy Wren skied there when he visited his Hayden cousins, but when a new elementary school was built in 1949, the hill was abandoned and "the older boys took up skijoring behind a car," Jan says.[75]

Fetcher adds:

The Edison School, which functioned from 1900 to 1947, was between Pine and Spruce Streets. It fronted Washington Avenue; the ski hill was across the street from the school. It is quite grown over and built up now. Up through the mid-1950s, U.S. 40 entered Hayden on Washington Avenue. The old right of way can still be seen in the meadows east of town. The Redstone Motel was built in 1948 on the site of the old Edison School and

is now an apartment complex. Solandt Memorial Hospital, built in 1923 and which gave the hill its name, is to the west overlooking the Hayden business district. The rope tow appears to have been a Lions Club sponsored project, according to an article in the Routt County Republican. *Donations of equipment and labor were provided by the community. The Cary Ranch, west of Hayden donated an old combine from which many parts were repurposed for rope tow use. Model A Ford parts (likely wheel rims for tower sheaves) came from the county maintenance shed. Furlong's Hardware furnished eight hundred feet of one-and-a-quarter-inch rope for a tow length of four hundred feet. The tow seems to have been short-lived, only two years. It may have been revived in the late '50s after the failure of the American Legion's ski hill attempt on the Arthur Parker/Holderness Ranch property southwest of town.*[76]

STEAMBOAT LAKE

Skiing was part of the way of life in and around the town of Hahn's Peak, up the Elk River from Steamboat Springs some twenty miles. Children skied to school, and tales of skiing prowess feats have been passed down through the years. The ski area that was Steamboat Lake was part of this legacy, but it wasn't close to Hahn's Peak or Steamboat Lake, really. It was located by Pearl Lake, which is south and east of them (GPS coordinates: 40°47'15"N, 106°54'16"W).

The developer was Lifetime Communities of Florida, and it envisioned Steamboat Lake as a resort with residential living, a golf course and more, including thousands of residents. In actuality, only the ski area and a few scattered homes in small subdivisions were ever built, and the ski area only operated for one year.

Eric Saenger of Golden worked at the area the one season it was open, 1973, under the management of Gordy Wren. He'd been coming to the area to stay in a cabin on the Elk and ski in Steamboat during Christmas vacations. According to Saenger, "We moved up to Clark when I graduated college. My dad had bought some property with a sawmill on it. The deal was, we moved up there, and I started to run the sawmill, worked at the ski area that one winter. Didn't have anything to do with building it, but I operated the snow cat, grooming the trails. That was my job."

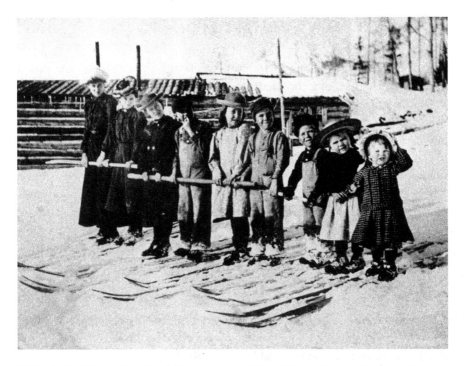

Hahn's Peak children ski to school. *Provided courtesy of Tread of Pioneers Museum, Steamboat, Colorado.*

He said Gordy Wren was a nice guy, and they worked together running the snow cats. "I remember pretty basic controls; [it was a] big tractor with wide treads on it, hard to turn it over. It was closed, had to stay out of the elements. They had one run that came down and went over a real drop off. The first time we went over that was kind of a real thrill. We're going down there? The instruction was to point it downhill."[77]

According to ColoradoSkiHistory.com the area had two Heron-Poma double chairs. One lift served beginner terrain with a capacity of 700 passengers per hour; the other served intermediate and expert terrain with a capacity of 1,200 passengers per hour. "Both lifts were removed during 1989 and one was relocated to Howelsen Hill in downtown Steamboat Springs."[78]

STAGECOACH

This was another developer's dream project and, if fully built out, would have been listed among the medium- to large-sized ski resorts in the state. It was another example of real estate development and skiing going hand in hand, as it has from the first. However, this story did not have a happy ending for skiers or developers.

"In the early 1970's, Woodmoor Corporation acquired land and began to plan a large new community named Stagecoach. Woodmoor envisioned Stagecoach Reservoir (lake area), ski mountain, golf course, and thousands of single family lots and multi-family units. Woodmoor received County zoning and approval of subdivision plats covering 1,938 single family lots and the potential for thousands of additional condominium and townhouse units (over 4,500 family dwellings). In 1974 Woodmoor experienced hard times and filed for bankruptcy."[79]

The ski area opened in 1972 with three double chairlifts and a half-finished lodge, plus some other buildings. It closed in 1974, providing a wonderful new Colorado ski experience for only a short time. There has been some development of town homes and houses in the Stagecoach community near and around the ski area, but the ski area has never reopened. In 1988, the Stagecoach Reservoir was constructed and a state park created, completing one component of the resort area dream. The lift lines and ski runs are easily visible from the surrounding area and from Stagecoach Reservoir State Park. The base area was located just off County Road 212 but is on private property (GPS coordinates: 40°15'9"N, 106°51'25"W).

4

Jackson County

Ranchers and Rope Tows

*We all have been young and we all know that boys and girls have to have some
exercise and enjoyment and hardly can be kept away from it. I know from
experience that when a boy or girl has a pair of skis they are not going to lay idle.*
—Carl Howelsen, 1917.

In sparsely populated Jackson County, winters have always been long and
hard and snow a challenge—whether you were dealing with blowing
snow in the middle of North Park or with snow piling high in the forests and
mountains that ring the park on three sides. But for a brief period during
the late 1940s and 1950s, the North Park Ski Club operated four successive
small ski areas to turn that white burden into a source of fun.

There may also have been a few less-formal ski slopes operated on
ranches from time to time. Eddie Gould told the story to Eric Harmon,
currently of Lakewood, and his father that he would sometimes pull kids up
a nearby slope with a World War II–era snow machine called a Weasel. This
impromptu skiing took place on many ranches and hills around the county.
One of these was located at the D.C. Johnson Ranch on the northwest side
of North Park near Coalmont.

But with ski developments taking off in nearby Grand and Routt Counties
and to the north in the Snowy Range area of Wyoming, no other ski areas
operated there after about 1957. Even though blessed with ample snow,
the ski industry just never took hold in Jackson County. One area, Seven
Utes Mountain near Cameron Pass, was seriously evaluated as a ski resort
development when Colorado was being considered to host the 1976 Winter

Olympics, but when Coloradoans rejected the bid, the Seven Utes was put on the backburner. Studies and efforts to develop the ski area continued on and off for several years and resurfaced again in 1993. However, opposition from environmental groups and many North Park residents finally put to rest the idea of a ski area at Seven Utes Mountain.[80]

Today, particularly with Cameron Pass open year round, there are a few popular areas frequented by cross-country and backcountry skiers: Cameron Pass (including Seven Utes Mountain) in the Colorado State Forest, where you ski and rent cabins and yurts; around Willow Creek Pass; and in areas near Muddy and Rabbit Ears Passes.

Much of our history about Jackson County ski areas is from an interview with Jerry Hampton, one of the early members of the North Park Ski Club. Jerry helped run rope tows and clear runs until he joined the army in late 1953. At least three or four of the local ski club members had been in the Tenth Mountain Division during World War II. One member of the club, Jack Greenley, would take old heavy military skis, cut them down, add metal edges and better bindings and turn them into useable downhill skis. Jerry owned only one pair of wooden skis, no edges.

Gould Ski Hill (North Park Ski Hill)

The Gould Ski Hill, also known as North Park Ski Hill, or Cameron Pass, was the first of the North Park Ski Club areas with a rope tow and was operated from about 1946 to 1951. The rope tow was reported to be 1,100 feet long with a vertical rise of 600 feet. The Gould Ski Hill was located at the base of Cameron Pass on the north side of the road on a south-facing slope with meadows and few trees (GPS coordinates: 40°30'12"N, 105°56'47"W). With the abundant snow in the area, the more easily skied open terrain overcame any disadvantage from the extra sun. This same area, or a nearby location, is reported to have been used as a less formal ski slope where you walked up to ski beginning in the 1930s.[81] Jerry Hampton indicated that there were quite a few good skiers at Gould Hill, including his brother, who was a bit crazier on skis than he was. There were also some mishaps. At least one woman, named Anna Marie, broke her leg there, as did Johnny Mallon, another local. Mallon ended up crippled, a tough turn for someone in the ranching business. In about 1951, the ski club moved its rope tow and operations to Pine Springs at the north end of the county.

Pine Springs Ski Hill

The Pine Springs Ski Hill was located on the hill behind the Pine Springs cabins along Colorado Highway 127 as it exits the north end of North Park (GPS coordinates: 40°56′53″N 106°13′21″W). The property was on the Follet Ranch, whose owner once experimented with cloud seeding to improve the snowpack. The ski hill included a rope tow and a ski course cut through the trees, which is barely visible now as a change in forest color where it has filled in with aspens. The North Park Ski Club operated Pine Springs Ski Hill for two or three years from about 1951 to 1953.

Dean Peak

Dean Peak is a small hill at the end of North Park near where the highways split to go to Saratoga or Woods Landing, Wyoming (GPS coordinates: 40°55′21″N, 106°16′54″W). Using old aerial photographs, we found the ski run on the north side of Dean Peak, which was accessed from a mine road located to the east of the hill. The Dean Peak ski hill operated for only one season in about 1953. It made use of the rope tow from Pine Springs. Jerry Hampton indicated that only a few of the North Park Ski Club members used that area, and at least some of the equipment ended up being used at Baker Mountain (see Chapter 1). A clutch mechanism used to control the rope tow at Pine Springs, Dean Peak and later at Baker Mountain can be found at the North Park Pioneer Museum in Walden.

5
Moffat County

Stepping Up for the Kids

In December 1963, I was a nine-year-old classmate of Cathy Cisar at Sunset Elementary School in Craig. I remember her and the accident that tragically took her life. I also remember sledding down the streets of Craig because that was the best place to sled although it was extremely dangerous.
—Dale Beck, 2009.

Moffat had one hill, in Craig. Like their neighbors in other counties, the people of the town made the hill for their children, but there it happened in response to a tragedy. It seems that something similar to what happened in other towns happened in Craig, also. The powers that be—for a variety of reasons, no doubt—did not continue to step up and keep the hill alive for the community.

CATHY CISAR WINTER PLAYGROUND

This area was created, and named, after the nine-year-old girl whose sled ran into a car. It was made to give the children of Craig a safe place to sled and ski.

Fetcher tells the story on ColoradoSkiHistory.com:

The accident happened 23 December 1963, just before Christmas. The people of Craig rallied to provide a safe place for their children to sled and

ski. Funds were raised to purchase about three blocks worth of land and build a warming hut. The Playground was dedicated 8 October 1967.

The hill was surveyed for a lift in August 1973, the lift to be installed the following year. Plans were drawn up for a Mighty-Mite wire-rope handle-tow, 876 feet in length with a vertical rise of 124 feet.

In January 1979 a child was injured in the workings of the tow. Two choices were faced; stiff regulations regarding operating the tow, plus liability insurance carried, or no tow and the hill used as it was before lift service was added. The second choice was adopted and the tow was removed.[82]

The hill was located at the end of Twelfth Street (GPS coordinates: 40°31'36"N, 107°33'10"W), and it did go through numerous changes through the years, according to a 2009 article in the *Craig Daily Press.* "A half-pipe was constructed in 1990 to coincide with the new craze in winter sports—snowboarding—and a towrope, bathrooms, lights and a warming shack were added, as well."

Jennie Lay of *Steamboat Magazine* wrote, "Craig's ski hill was the highest rise in the neighborhood. A single, treeless run off the front of the rope tow enabled many local kids who couldn't get over to the Steamboat Ski Area to learn their turns. The free tow was closed in 1980, when a child lost a thumb in the machinery and liability concerns prevailed."[83]

"Now, the towrope is gone, the lights no longer work, and the warming shack is all closed up—Moffat County Parks and Recreation stopped maintaining the hill years ago."[84] The hill is not entirely lost because Craig residents use it for sledding still. However, Dale Beck doesn't think that's good enough. He commented, "Someone should organize a fund raiser and give new life to the old hill. Restore it to how it was during its prime days...Let's go Craig residents. Meet my challenge. Give the old hill new life!!!"[85]

6

Jefferson County

Glory Days and Mom-and-Pop Areas

We all had our special secret formulas for ski wax. As I recall, mine was six parts paraffin to four parts beeswax with one drop of oil of coriander and a dash of paprika. (I may have confused this with my gin recipe but no matter: the wax was no good anyway).
—Henry Buchtel, 1939 [86]

Where the plains meet the foothills of the Rocky Mountains, nature provided some pretty good hills and sometimes enough snow for skiing. While the ski carnivals were all the rage farther west, here ski enthusiasts developed ski clubs and held ski tournaments for folks interested in the sport, and they developed ski areas for them as the interest grew.

Author Annie Gilbert Coleman wrote, "By the twentieth century Colorado skiing had moved from the realm of skiing mail carriers and isolated communities to the ski clubs of Denver and local winter carnivals." [87]

One of the first clubs was the Denver Ski Club, founded by Carl Howelsen and his Denver friends, which became the Denver Rocky Mountain Ski Club. The Colorado Mountain Club, also founded early in the twentieth century, arranged outings for their members. Homewood Ski Club was another early club. The University of Colorado (CU) and Colorado State University (Aggies or CSU) formed teams of student skiers, the Aggies. The University of Denver (DU) created a Pioneer Ski Club. Other clubs developed through the 1920s and 1930s, including the Allens Park Ski Club, the Rocky Mountain National Park Ski Club, the

The Aggies ski team poses. *Courtesy Colorado State University, Fort Collins, Colorado.*

Pikes Peak Ski Club, the Woodbine Ski Club, the Silver Spruce Ski Club and the Arlberg Club.

The clubs and the competitions included women in the sport and in the fun. "The Denver-Rocky Mountain Ski Club tournament in 1922 offered girls' sliding," wrote Gilbert Coleman, "ladies' sliding and ladies' jumping contests, for instance, along with boys' and men's jumping, cross-country, and 'fancy skiing.' Girls and ladies also jumped at St. Mary's Glacier in 1923."[88]

Josephine Shelton told about skiing in Jefferson County in the 1920s, saying that women and girls had no fear because it would have been "sissy" to be afraid. She made a thirty-one-foot jump at St. Mary's Glacier during the Fourth of July tournament, after telling her girlfriends, "By gum, why don't we go for it."[89] Of course, women and girls had been using Norwegian skis to get around and do chores here, as in other parts of the state, alongside the men and boys.

The ski areas developed according to the interests of the people, supply and demand being the driver as it was elsewhere. They sprouted up close to where Colorado Highway 40 was completed in 1938 and Interstate 70

was finished in 1972[90] and where Colorado Highway 285 is today. Initially, people had to drive the "Lariat Trail" up Lookout Mountain. Other ski areas were planned but never got started.

Many of the well-known names of the early years of skiing were involved in developing the areas in Jeffco, including Carl Howelsen and Thor Groswold. First there was ski jumping at Genesee, the first mountain park Denver acquired, and at private Homewood Park. As Alpine skiing came west and gained in popularity, mom-and-pop areas sprang up for local people to enjoy the new type of skiing with their families.

The development of technology for Jefferson County areas seems to have been driven by demand, as well. At Mount Lugo, skiers were transported by horse and sleigh to the top of the hill. The same was true at Rilliet Hill, where they later used automobiles. Enterprising men, who were good with machinery, devised boat tows and rope tows to get more people up for a price or to even make snow.

In the end, all the ski areas in Jefferson County disappeared, but they gave great enjoyment to Denver-area skiers. Others were planned and never materialized, such as Evergreen Basin, which still provided some skiing to people. And still others were small areas that served locals, such as Pence Park near Kittredge. Some areas closed because of financial problems, others because of conflicts with local residents or government land management agencies and still others because of the economic hardship of the Great Depression and then gas rationing during World War II, as in other areas of the state.

GENESEE MOUNTAIN

This was a thrilling place to be in the 1920s and 1930s. After ski jumping at Inspiration Point at the border of Denver and Jefferson Counties introduced the sport to Denverites, skiers headed to the foothills and Denver's first mountain park south of Interstate 70 at Lookout Mountain for more and better of the same. "The newly named Denver Winter Sports Club commenced the construction of a jumping course in 1919…They planned to offer a longer jump by building a ramp east of the summit."[91]

The Ralston family leased land to the Rocky Mountain Ski Club for a ski jump on the mountain east of the Denver Mountain Park (GPS

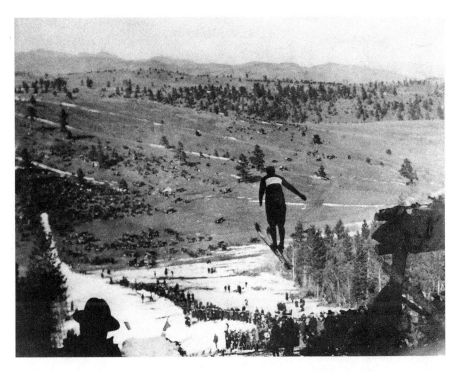

Jumping at Genesee was a thrill. *Courtesy Jefferson County Historical Society and Hiwan Homestead Museum.*

coordinates: 39°42′1″N, 105°16′57″W). They helped build the jump, which Carl Howelsen helped design, and created the warming house, which was reputed to sell dainty Norwegian pastries, among other things. Also, real estate development became part of the picture when the family sold summer cabin lots at the top of the jump. (Eventually, the Ralstons sold 350 acres to developers, but that was not until 1964.)

Jumping was the big attraction in skiing at the time. "The Genesee ski hill was 1,000 feet long and had a 35 percent grade. Thousands came to watch the 'ski riders,' especially on the day a single-engine airplane pilot won a race against the jumpers."[92]

The tournaments at Genesee caused great excitement, but none more so than the Sixteenth National Ski Tournament of America, which was held there February 19–20, 1921.

Denver Municipal Facts, a newsletter of the city and county of Denver, whipped up interest with a write-up in their January–February issue of that year. The newsletter thought the contest would be the "means of

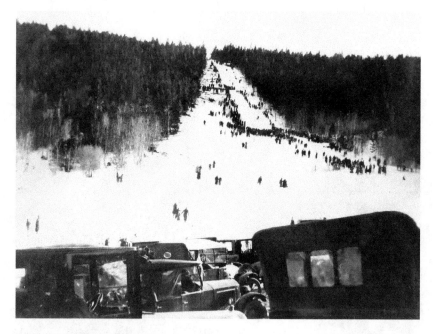

The ski hill at Genesee was the place to be. *Courtesy Jefferson County Historical Society and Hiwan Homestead Museum.*

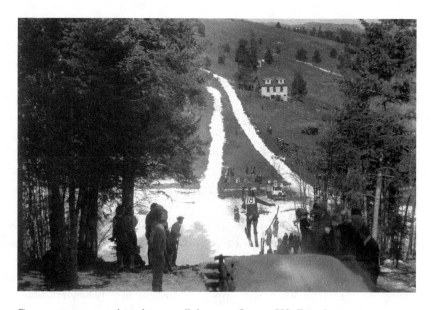

Genesee tournament jumping was all the rage. *Courtesy U.S. Forest Service.*

popularizing the 'great Norwegian sport in Denver.'"[93] The Denver Rocky Mountain Ski Club was pretty sure that Colorado would become the home of tournaments because of the plentiful snow in the state.

It was a lot of work to put on a national tournament, but people worked together. "Due to the co-operation between various organizations interested in the tournament and the city administration of Denver the exhibitions will be free to the public. Two slides are being specially constructed for beginners and the tournament will afford an unusual opportunity to those who wish to learn how to ski...An improved takeoff has been erected and some twenty members are working on the hill regularly to place it in the best possible condition."[94]

The tournament was a success in more ways than one; not only did it bring forty to fifty thousand spectators from Denver in some seven thousand cars, but according to Carl Howelsen, it brought the eastern skiers and the western skiers together. It also legitimized western skiing. Howelsen won first place in the professional category. Leif Howelsen said it was a real joy to his father and shared what the *Rocky Mountain News* wrote on February 21, 1921: "Skimming down over ice then hurtling out through space at the terrific rate of one and one-third miles a minute Carl Howelsen of Steamboat Springs, Colorado, easily won the professional ski riders championship of the United States for 1921 yesterday afternoon on the Denver Rocky Mountain Ski Club's course on Genesee Mountain."[95] Peter Prestrud won the Colorado amateur championship, and Hollis Merrill of Steamboat Springs took second in that category.

As the sport grew in importance and notoriety, people around the state kept up with what happened at the subsequent tournaments. An article in the *Estes Park Trail* reported on the 1924 tournament:

Combs Wins Ski Title

Carl Combs of Steamboat Springs is wearing the Rocky Mountain ski crown.

He earned it Sunday in the All-Western Ski tourney staged on Genesee Mountain near Denver.

His total points were 246. He made jumps of 106, 105, and 116 feet respectively.

The weather was perfect for skiing, the thermometer at the slide reading 25 degrees above zero.

No records were broken, but some were equaled. Spills were many and the spectators were treated to thrills galore. The various events proved,

however, that Colorado is producing a brand of skiers who will make names for themselves in the national tournaments.

In the women's events Gladys Wallace of Hot Sulphur Springs and Leila Erickson of Homewood Park, divided honors.

One of the riders was only 10 years old.

The meet was a great success. The interstate tourney will be held February 24.[96]

Josephine Shelton shared some of her memories with John McMillin in 1997. Her dad got her skiing. She said, "He had a car very early on...At the Kiwanis Club, we were invited to go up to Genesee to ski and he took the whole family up. What we got for Christmas was skis."[97] She added that some spectators took the streetcar to Golden, rode the funicular up Lookout Mountain and then walked miles to the Genesee course.

New jumps were built over the decades when Genesee Mountain was used and enjoyed: *City and Mountain Views* noted that the longest jump was said to be 2,000 feet with a vertical drop of 700 feet and reported, "A new course record was set with a 117-foot long jump in 1922. One of 125 competitors stretched 152-feet in 1931, but only 1,000 spectators were on hand."[98]

One of the ski riders of Genesee had quite an impact on other ski areas in Jefferson County. His name is Covert L. Hopkins, and he was called Hoppy. He made a jump of 121 feet in 1923 and held the record for a while. Also, he was known for jumping in tandem with another jumper, making dual jumps on the hill. He also served in the Denver Rocky Mountain Ski Club in various capacities and was a tournament judge and chief-of-hill for later tournaments.[99]

The snow seemed to give out and interest waned until there were only eight thousand people to view a 1933 tournament, which the *Denver Post* sponsored. The Denver Rocky Mountain Ski Club disbanded, and the hill was abandoned, possibly due to the economic hardship of the times. It was revived for training for DU students in the 1950s by Coach Willy Schaeffler. College tournaments were held there for three years with Lewis Dalpes as judge. The last year of skiing there is said to have been 1956.

Watson's Ski Hill

When Covert Hopkins asked rancher Horace Watson, who was a retired boxer and who was operating a walk-up ski hill and toboggan run on his place (GPS coordinates: 39°32′42″N, 105°11′23″W), if he could build a tow and more trails for skiers there, Watson agreed and signed a lease with him for five years. Loren Fender, who owned a local garage, got in on it too. Fender and Hopkins became partners. They had a lot of work ahead of them.

Lew C. Hopkins tells the story:

> *In the summer of 1938, my father laid out the tow line and ski runs at Watson's, and, with the help of Loren, cleared the timber, all by hand. He designed, and with the help of Loren, built a sled tow (sometimes referred to as a boat tow) operated by a steel cable attached to the sled and to a mine hoist at the top of the hill. Unlike other boat tows of the time, this sled tow was designed with a stepped wooden platform to allow skiers to simply move onto the sled with their skis on and move off again at the top. As I recall, the stepped wooden platform was built on a welded steel framework. This sled had steel pipe runners, bent upward at each end and capped. There was a rack at the lower end of the sled made of a steel pipe frame supporting a chicken wire basket, so that skiers could also take their skis off if they so desired, put them in the basket and sit on the steps while riding up. I learned to ski at this area, and when the sled was full of paying skiers, Dad would let me ride up by sitting in this basket.*
>
> *The hoist for the sled tow was enclosed in a small wood building with a seat for the operator and a window to enable him to view the entire tow line. The hoist was operated by Loren Fender while my dad rode at the lower end of the sled and supervised the stopping and loading of the sled at the bottom. As the sled was lowered on its cable, Dad would signal Loren when to stop the hoist by waving a red flag. After the sled was loaded with skiers, he would signal again with the red flag to let Loren know it was time to pull it back up. At the top of the hill, the skiers would unload, and the empty sled would be lowered again to pick up the next group of skiers at the bottom.*[100]

Watson's Ski Hill charged skiers ten cents a ride. Or they could purchase an all-day ticket for fifty cents on Saturdays and seventy-five cents on Sundays. Mrs. Watson operated the warming house and served food to the skiers.

A Homewood Park tournament poster shows the program. *Courtesy Jefferson County Historical Society and Hiwan Homestead Museum.*

Hopkins reports that the rancher decided to break the lease he had made with his father and Fender and run the ski area himself and that, though he tried to do so, the ski area failed after a couple of years and was lost. It would later become Fun Valley in the 1960s.

HOMEWOOD PARK

Beginning in 1928, two Scandinavians, Leif and Andrew Erickson, hosted ski jumping meets at their ranch, about five miles above the entrance to South Deer Creek Canyon (GPS coordinates: 39°32′28″N, 105°12′7″W).

There was no lift; skiers hiked up to make their jumps from a hill that some have called formidably steep. You got your exercise at Homewood as well as your thrills. An ice-skating rink was also a feature at Homewood Park.

Participants gathered for Homewood Park tournament day. *Courtesy Jefferson County Historical Society and Hiwan Homestead Museum.*

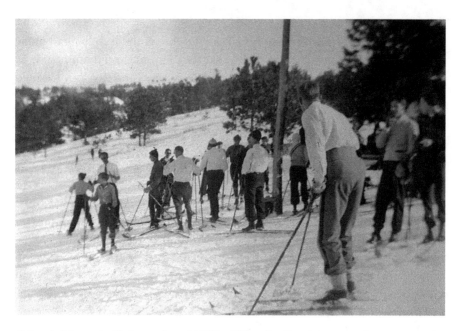

Colorado Mountain Club members ski Rilliet Hill on Lookout Mountain. *Courtesy Woody Smith, Colorado Mountain Club archives.*

"A full day at a Homewood Park meet included a practice run and three jumps for a score," according to Lewis Dalpes, who told his story in 1997. "That was a beautiful hill."[101]

Some say skiing continued there until 1940 or so. However, ColoradoSkiHistory.com reports that a sled tow was added at Homewood in 1942. Perhaps World War II ended the fun. Skating continued until 1969.

One story about Homewood centers on a woman who jumped there: Joanna Kolstad, a Norwegian who had jumped 180 feet and beyond. During one jump, she caught a gust of wind and nearly pancaked to the ground. However, as the crowd gasped, she held on and executed "a miraculous recovery" and landed at 106 feet. Another story has Lewis Dalpes in the middle of the runout after a jump when a car crossed his path. "He flung himself down flat to the snow like a ball player sliding toward home plate and slid underneath the passing Model T."[102] He came out of the near miss with only a wrenched ankle. The Ericksons shortened the jump before the next competitor sailed.

The Denver Rocky Mountain and Homewood Ski Clubs had a friendly rivalry at Homewood Park.

Rilliet Hill

This was property on Lookout Mountain that was owned and run by the Colorado Mountain Club (CMC), but we've been unable to locate the hill, so we do not provide GPS coordinates here.

The club often took members to other areas for cross-country skiing. "It also took many ski trips to Rilliet Hill, located on Lookout Mountain. Here skiers trekked up and skied down to learn and to perfect their telemarking techniques, assiduously avoiding the barbed-wire fence which stretched across the bottom of the slope."[103]

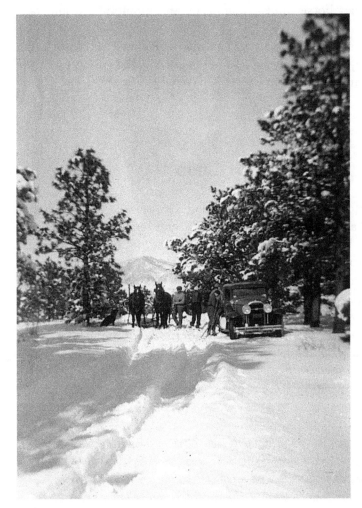

Horses and horsepower transported skiers to Rilliet Hill on Lookout Mountain. *Courtesy Woody Smith, Colorado Mountain Club archives.*

In 1939, CMC skiers had to make up their own ski wax. Henry Buchtel continued his tongue-in-cheek story about the wax:

This was melted on the stove, thoroughly mixed and poured into jelly glasses to harden. We ironed it onto the ski. It wouldn't slide downhill, nor would it stick enough to allow climbing. In wet snow each ski weighted so much that the muscles so hypertrophied have never atrophied. The same formula with the addition of two parts of linseed oil, one part of whale oil, and a lemon rind was used for shoe grease.[104]

The skiers would climb up and practice their telemarking on the way down. Sometimes horses and a wagon, or an automobile, would take them up.

CMC members bought land and formed a Rilliet Park Association and from it they later donated a 273-acre conservation easement to the Clear Creek Land Conservancy in 1997. We were not able to locate the ski hill.

Mount Lugo

When Covert Hopkins and Loren Fender lost their lease on the ski hill they developed at Watson's Hill, they bought 173 acres in a basin on the north face of Mount Legault. They changed the name because they thought Mount Lugo would be easier to pronounce. They created a new ski hill there (GPS coordinates: 39°32'11"N, 105°16'46"W). It was a big job to get a ski area set up, as it had been in Watson's Gulch. Loren Fender sold his share in 1940, but not until after he had helped Hopkins survey the land, build a road up to the areas, lay out and clear timber from the lift line and trail and build a warming house. They even had to build a bridge over a deep ravine.

Then, Hopkins had to solve a unique problem, according to his son Lew Hopkins:

Because the road up to the area was inaccessible in winter, skiers had to leave their cars parked along the highway or in a field across the highway. To get skiers up to the hill, Dad arranged with the son of a neighboring rancher to carry them up the road on a hay wagon sled pulled by two draft

horses. I believe the young man's name was Dean Blakeslee, and I think he charged twenty-five cents round trip for the ride up to the warming house. He would make trip after trip up and back as long as there were customers. Skiers could ride the sled back down to their cars at the end of the day if they wished; however, most of them chose to ski down the road because it made a very nice, long run. As it turned out, many non-skiers would come up from Denver just to ride the sled up and back.[105]

There was a warming house with a wood-burning cookstove and a handy chicken wire rack above the stove around the metal chimney where skiers could dry their gloves. Food served there included hamburgers, hot dogs, chili, pie and donuts, plus drinks, warm and cold, served by the wives of the owners. They brought the makings for the food up in the sleigh in the early mornings.

According to Lew Hopkins, the ski hills included a short, walk-up hill just above the warming house, but the main ski hill was to the left of the warming house. It was a long, wide trail. It had a 1,200-foot rope tow that was operated by an old Buick car engine and chassis:

The Buick chassis had a large pulley attached to the right rear axle to power the rope tow. To keep the rope properly tensioned, the car chassis was on skids set on top of a long, downward-sloping wooden platform with a large concrete block weight attached to it by a cable and suspended over the lower end of the platform. This weight moved up or down over the edge of the platform so the rope would always remain tensioned whatever the skier load might be...Gasoline to operate the engine had to be carried from the warming house up to the base of the tow by hand in five-gallon cans, one of which is still there. This was a fairly long distance, and I remember Dad struggling through deep snow at times, trying to carry two five-gallon gas cans. The war stopped any further operation or development of Mount Lugo. The attack on Pearl Harbor occurred on December 7, 1941, and by the end of the ski season in the spring of 1942, gas rationing was in effect and the country was firmly entrenched in the war effort. Dad was working as a painter throughout the war at various military bases, many of them away from home, so he couldn't operate the ski area. Additionally, because of severe rationing during the war, few people had gasoline to drive anywhere for pleasure. Dad never opened the ski area again after the war ended in August of 1945.[106]

The area had enjoyed some pretty good ski days, including one when twenty-five CMC members came to ski.

The Hopkins sold their land to the Meyer family in 1970. Jefferson County Open Space acquired it and created the Meyer Ranch Park property. When you go to hike or cross-country ski or slide on tubes on that property, which people often do, be sure to look for "Ski Hill Trail" on the sign in the park.

MAGIC MOUNTAIN

In 1958, George "Lefty" McDonald launched a ski area as the Foothills Ski Corporation south of what is now the alpine slide at Heritage Square (approximate GPS coordinates: 39°42′38″N, 105°12′35″W). His first choice had been to build a ski area on Green Mountain at Sixth Avenue and Interstate 70, but that plan failed.

According to ColoradoSkiHistory.com, Magic Mountain featured a Hall double chairlift. A flier shown on the website indicates it was open every day from noon until 11:00 p.m. with floodlights for night skiing, a warming house and snack bars, and it had two one-thousand-foot tows, ski rentals and certified instructors.

However, the most surprising aspect of the ski area was a discovery that happened accidentally, something that would allow this unlikely little area to impact the entire ski industry.

John McMillin wrote about McDonald's discovery in 1997: "His company leased about 60 acres south of the present Alpine Slide (Heritage Square) then known as Magic Mountain. They brought in standard water hoses and irrigation rigs and attached their secret weapons—a patented spray nozzle, developed by a Massachusetts irrigation firm."[107]

McDonald said that things evolved accidentally; they had been spraying trees when the temperature was below freezing, and they got snow. He put the technology together and created a snowmaking system, the first in the western United States, and he was able to build up a base of two feet for the ski area, he said, and have some success with it.

Sadly, the amusement park failed financially and closed. McDonald had to buy his snowmaking equipment back. When he did, he sold it to Ski Broadmoor in Colorado Springs and went there to work.

The Moffat Road connected plains communities and mountain towns, transporting skiers to winter carnivals, hills and resorts. *Caryn Boddie collection.*

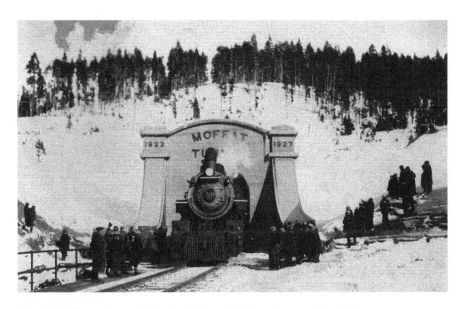

The Moffat Tunnel pierced the Continental Divide under James Peak. Its completion changed skiing in Colorado forever. *Caryn Boddie collection.*

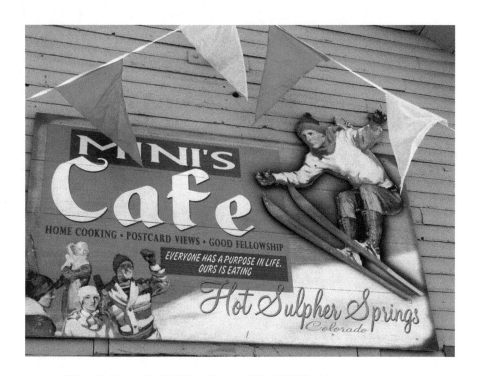

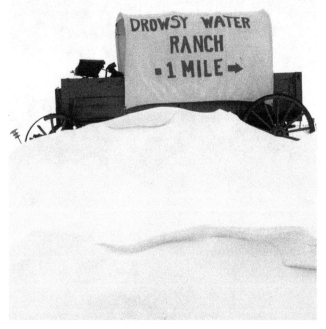

Above: Café sign celebrates the ski riders who dazzled spectators at Bungalow Hill in the early 1900s. *Caryn Boddie photo*.

Left: Wagon on U.S. Highway 40 points the way to a dude ranch, still open today, which once had a ski hill with a boat tow for winter guests. *Caryn Boddie photo*.

Skier Rides Chairlift on Emerald Mountain, by Reginald "Rex" Gill. *Courtesy Tread of Pioneers Museum, Steamboat, Colorado.*

"Summit of Berthoud Pass and the Twin Chair Ski Lift." *Published by Sanborn Souvenir Co., Inc. Caryn Boddie collection.*

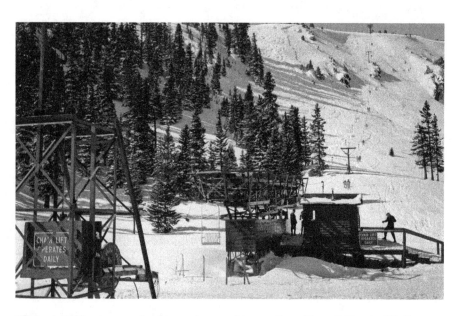

"Twin chair lift transports the skier to the top of an excellent ski run." *Photo by C.C. Patterson. Caryn Boddie collection.*

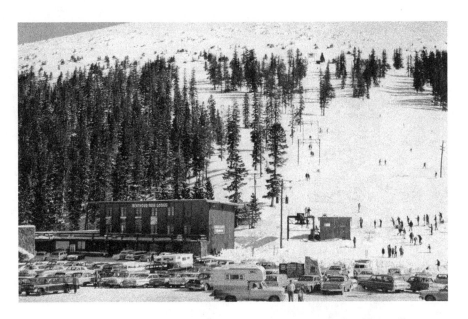

Berthoud Pass Ski Area. "View shows T-Bar Ski Tow and skiers enjoying this excellent winter sport." *Photo by C.C. Patterson. Caryn Boddie collection.*

The unique lodge at Apex Ski Area held up pretty well. *Courtesy Gilpin Historical Society.*

DENVER'S CLOSEST

Central City Apex Area 1947

47 MILES FROM DENVER
7 MILES PAST CENTRAL CITY

APEX SKI TOW TICKET

47 MILES FROM DENVER
7 MILES FROM CENTRAL CITY

Rate: $1.00 a day

DENVER'S CLOSEST

Central City Apex Area

47 MILES FROM DENVER
7 MILES PAST CENTRAL CITY

Left: Apex Ski Area tickets from the Gilpin Historical Society Museum remind us that skiing really took place nearby. *Peter Boddie photo.*

Below: Skiers had fun on St. Mary's Glacier year round, and especially on the Fourth of July. *Postcard collection, Scan 10042909, History Colorado, Denver, Colorado.*

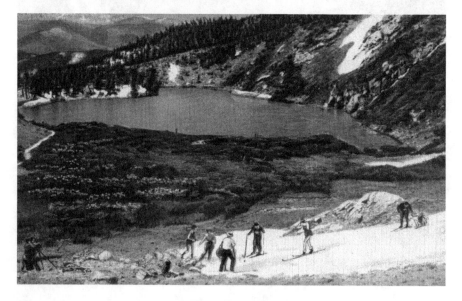

THE NATIONAL FORESTS

America's Playgrounds

yours to enjoy...

ski safely!

Above: Flywheel of the chairlift remains at Ski Idlewild years after the area closed. *Caryn Boddie photo*.

Left: The U.S. Forest Service has played a major role in managing Colorado's ski areas. *Peter Boddie photo*.

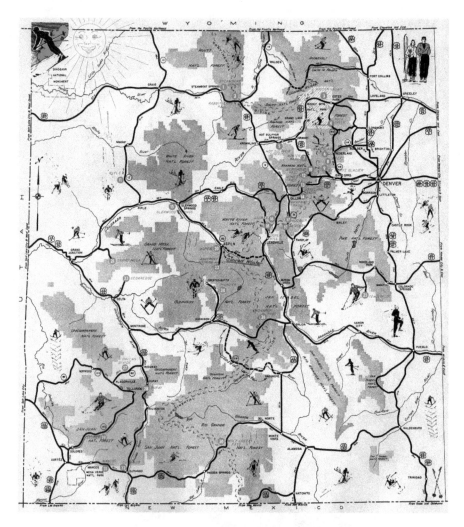

This U.S. Forest Service map appeared in *Colorado Wonderland* (December 1952) and shows several now lost areas. *Caryn Boddie collection.*

Opposite, top left: University of Denver (DU) Pioneers nordic skier Joern Frohs competes in "Super Saturday" on Snow Mountain in 1999. *Courtesy of University of Denver Special Collections and Archives.*

Opposite, top right: Fashionable female skier strikes a pose in the 1950s. *Postcard published by Noble, Colorado Springs, Colorado. Caryn Boddie collection.*

Opposite, bottom left: Arapahoe East was meant to be a fun family area, as the brochure reflects. *Courtesy Brad Chamberlin, www.coloradoskihistory.com.*

Opposite, bottom right: Brochure advertises Hidden Valley. *Courtesy Brad Chamberlin, www. coloradoskihistory.com.*

A130 TEPEES-DENVER MTN. PARKS, COLO.

arapahoe east

FUN SKIING...
JUST MINUTES
FROM DENVER!

GREAT
NIGHT
SKIING!

TWENTY
MINUTES
FROM MY
OFFICE!

PAY
BY THE
RIDE!

NEVER
CROWDED!

Rocky Mountain National Park
Colorado

SKI
HIDDEN VALLEY

...at Estes Park

The Poma lift still stood at Fun Valley Ski Area decades after the area closed. *Caryn Boddie photo.*

Top: Flywheels on the Poma lift stand out against the sky at Fun Valley Ski Area. *Caryn Boddie photo*.

Left: Sexy spring skiers pause during a run. *Postcard published by Noble, Colorado Springs, Colorado. Caryn Boddie collection*.

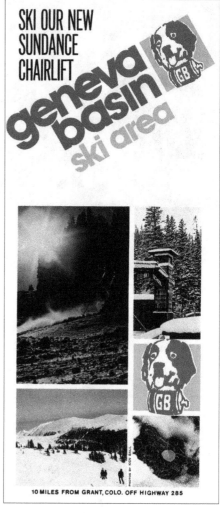

SKI OUR NEW
SUNDANCE
CHAIRLIFT

10 MILES FROM GRANT, COLO. OFF HIGHWAY 285

1985–86 Season
P.O. Box 65 Grant, CO 80448 303-674-4666

Above: Geneva Basin brochure shows the Saint Bernard mascot. *Courtesy Brad Chamberlin, www.coloradoskihistory.com.*

Top, left: Wooden skis evolved into alpine skis. *Caryn Boddie photo.*

Left: Geneva Basin brochure has a more-modern look. *Courtesy Park County Historical Society.*

It was a great day for skiing at Geneva Basin. *Subject File collection, Scan #10042910, History Colorado, Denver, Colorado.*

Indian Mountain sticker graces a bench made out of snowboards. *Caryn Boddie photo.*

Snowboarder B. Tim Nicklas wears evidence of his last run. *Courtesy Grand County Historical Association, Hot Sulphur Springs, Colorado.*

If you're ever on Buffalo Pass look for this great view of Emerald Mountain. *Courtesy Bill Fetcher.*

A University of Denver ski team member catches air. *Courtesy of University of Denver Special Collections and Archives.*

An ad from *Colorado Wonderland* Magazine, December 1952, tells why Colorado is the place to ski. *Caryn Boddie collection.*

The site of the lost Magic Mountain was dug away as a quarry pit. However, the double chair was still used for the Heritage Square alpine slide.

Fun Valley

Horace Watson, who had leased land for and then run Watson's Ski Hill in the 1930s, tried again in the 1960s and renamed the area Fun Valley.

ColoradoSkiHistory.com lists some stats about the area, including dates of operation from 1965 into the 1970s. The website states that there was a single chairlift, which came from Arapahoe Basin, a rope tow and a "platter" that was "built by Poma with a length of 1060', 230' vertical, and a capacity of 800 pph."[108] The area offered night skiing and snowmaking, and it had a warming house.

John McMillin wrote, "In 1969, Fun Valley offered a J-bar Poma lift and a rope tow, which could transport 1,500 skiers per hour. It placed the area in the first ranks of Colorado's second-string ski areas. Skiing continued at Fun Valley under lights."[109] Some said that good things about the area were that it had a good protected slope and no crowds, and it was an after-work alternative for skiing.

Fun Valley closed in 1977, after having had several different owners, and its blue single chairs off the chairlift were sold off as souvenirs. In 2014, its Poma lift was still standing (GPS coordinates: 39°32′42″N, 105°11′23″W).

Arapahoe East

Arapahoe East was located up Mount Vernon Canyon, a couple of miles from the exit to Red Rocks and Morrison on I-70 (GPS coordinates: 39°41′46″N, 105°14′31″W). Motorists noticed it as they drove the canyon. Starting in 1972, there were skiers coming down the slope on the north side of Mount Lininger. After 1984, there were just lift towers to see.

Larry Jump is known to have been the driving force behind Arapahoe East. In 1971, Charlie Meyers wrote in his regular column "Downhill Beat" about what the ski-area veteran was trying to do. "Jump, the man who brought us skiing by reservation only at Arapahoe Basin last year,

now has invented the world's first token-operated ski area. It's all a part of a unique pay-by-the-ride scheme Jump feels will fit right in with the Arapahoe East concept."[110] Jump explained in the article that a person could ski as much or little as he or she wanted at an area close to town and that the skier would get more value with a per-ride charge. Tokens were twenty cents each, with one being charged for the Poma and two for the chairlift.

Marnie Jump spoke with John McMillin in 1997 about her husband's goals: "There were two motives. It was Larry's idea that it would be a feeder area for beginners, who would eventually go on to ski at Arapahoe Basin. And we wanted to tap into the market of city skiers."[111]

Meyers wrote about Arapahoe East again for the *Denver Post* in 1979 and about Larry Jump:

> *And on Wednesday he revved up the lifts at Arapahoe East, that monument to fuel economy just 15 miles from downtown Denver at the edge of the foothills off Interstate 70. Arapahoe East has 450 feet of vertical, one double chairlift, a Poma, and a Mitey Mite, prices to fit any budget and a very low tolerance to warm weather...There was a time when it seemed as if Arapahoe East might never be open at all. Since Jump first opened the area in 1972, after selling Arapahoe Basin, it has gone through a series of fits and starts. The fits have come when weather and snow have not been sufficient to support skiing on a sustained basis, the starts when Jump returned his sailboat to port to crank things up when another interim manager bit the dust, literally.*[112]

The column gave the picture that, possibly because of the challenges, Jump had a love-hate relationship with the ski area. He had a buyer lined up in 1978 if an alpine slide could be installed. "But following an extended battle, Jefferson County Commissioners turned down the application for the slide. Exit Buyer."[113]

Some of the issues that caused the commissioners to turn down the permit included an association with another resort in New Jersey that included a Playboy Club. Also, Mount Vernon Canyon residents were opposed.

Marnie Jump said that the public hearing about the changes was the most horrible experience of her life. "I had never seen such anger and resistance. It was very discouraging. It made me angry, because we had run such a good, clean family area. Neighbors who had left their kids for

baby-sitting at Arapahoe East showed up at the hearing to rail against any further development there. It hurt when they were so hateful to us."[114] Jump sold the land to the Medved family in 1995, and they removed the towers a year later. It turned out that Arapahoe East broke even only one year: 1973.

However, a lot of people had a good time working and skiing at Arapahoe East. You can read some of their stories at ColoradoSkiHistory.com.

7

Douglas County

Getting In on the Craze

Miss Annie Beaman is spending an enforced vacation at home the first half of this week on account of not being able to get up through the snow in Jarre Canon to Woodbine Lodge.
—Record Journal of Douglas County, *1936.*

A ccording to an advertisement in the *Record Journal of Douglas County*, "seven miles west of Sedalia on the Sedalia-Deckers road"[115] was a summer resort called Woodbine Ranch. The newspaper covered activities there for years. Its claim to fame was a good chicken dinner. Sometimes

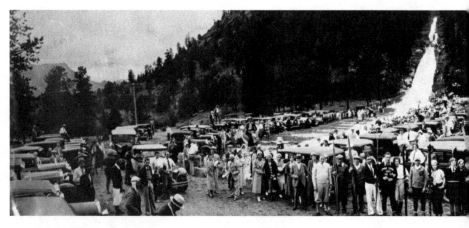

Douglas County gets in on the fun with the Woodbine ski jumping tournament, 1931.
#2000.018 Douglas County History Research Center.

its guests dined on bear meat. There was a celebration on the Fourth of July in 1921 with bronco busting, steer wrestling and picnicking. The ranch welcomed a silver fox farm to its property in 1922. The Knights Templar and Shriners met there for a picnic in 1924. The same year, Leland Verain (aka Two-gun Alterie or Diamond Jack Alterie) and Dion O'Banion, who was the head of the Chicago gang in opposition to Al Capone, asked someone to film a rodeo there.

One other remarkable event took place there—this time in winter. In 1931, the ranch welcomed a ski jumping tournament. "Quite a number from here enjoyed the Ski Tournament at Woodbine Lodge Sunday afternoon," reported the *Record Journal of Douglas County*.

It's unclear how long the ski jump had been there, who built it or how long it remained, but we do know that folks in Douglas County got in on the ski jumping craze for at least one day.

The lodge burned down in 1945, was rebuilt and then became, in turn, a country club and a Baptist camp. We are uncertain of the location of the ski jump, but it is presumed to be somewhere near the Woodbine Ecology Center.

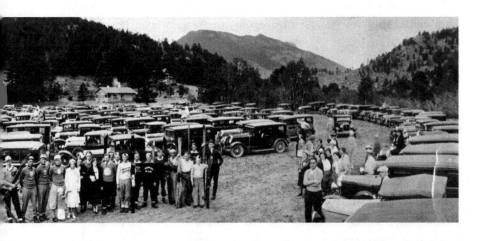

8

Teller County

Hard Work Plus Snow Equals Fun

Back then, the ski clubs built all their areas with donations and with volunteer labor. We never had any money, and we had to improvise and make do. We worked hard, we skied hard and we had a wonderful time.
—Don Lawrie

The excitement of skiing spread to the southern Front Range when a few young men—Clarence Coil, Doug Sheafor and John Fowler—went up to Genesee Mountain from Colorado Springs and watched a jumping tournament.

It was eight years after Carl Howelsen had gone home to Norway for his parents' golden wedding anniversary, never to return. His presence and his influence had done what they were meant to do perhaps; it seems to have been perfectly providential. The ski areas of Pikes Peak, also called the Catamount area, which provided the people of that region happy times and healthy sport, would have pleased him.

Fourteen years before Coil, Sheafor and Fowler saw the ski jumping, Spencer Penrose had envisioned and started building a road to the summit of Pikes Peak using the old carriage road to the top. At the time they made their excursion, it was a toll road that charged two dollars a car, and Penrose had a permit with the U.S. Forest Service for it.

"As a result, throughout the 1920s and into the 1930s, skiers accessed the mountain by train on 'ski outings.' As early as June 1924, a ski-jumping competition was held on the mountain."[116] Those men who had gone up to Genesee to watch the action were inspired; they went back home and cleared off different hillsides

Youngsters had been finding other ways to ski in Teller County already. The three men who went up to Jefferson County and Don Lawrie, Ben Hardy and John Rollins had already cleared a ski area and were using it. "In the early 1920s, they cleared a hill at the Fig Leaf Ranch near Midland, Colorado (partway between Divide and Cripple Creek). The ranch belonged to Don Lawrie's parents. The young men used it as their own private ski hill, hiking or side-stepping up the hill and skiing down."[117] And others had been jumping nearby.

Don Lawrie told the story: "I started skiing up on the ranch in the early 1920's. As a lad in Illinois I tried sliding down hill on old barrel staves. There were two or three fellows I'd gotten acquainted with down in town and they liked to ski, so we cleared a little place on up from the ranch. We didn't have much business but we skied up there."[118]

Of course, building a ski jump had to be in the picture, but you have to wonder if Coil, Sheafor, Fowler and all their friends had any idea how much work they'd have to do because you don't hear of their continued participation in the ski hills. Who knows? Maybe life just took them to other places. Anyway, the men were young, so they pulled together and managed to clear off a hill for jumping at Edlowe. Then, they started the Silver Spruce Club in 1928 and invited others to join. That was the beginning of the beginning.

EDLOWE

Edlowe (approximate GPS coordinates: 38°57′42″N, 105°5′12″W) was a small town and siding for the Midland Terminal train between Woodland Park and the Great Divide. There are accounts of more than one ski hill or ski jump built in the area by members of the Silver Spruce Ski Club, but the exact locations are not clear and any evidence may have long since disappeared. The first of the hills included a ski jump and was called Suicide Hill, but what they created wasn't the best for jumping; it was reported to be too straight up and down. The club went on to build another ski jump a short distance away, on the Silver Spruce Ranch. The club leased the hill from the rancher, E.J. Merriman, for ten dollars a month.

Lawrie joined the ski club after it was started. His story is told by his daughters in a memoir:

We decided this hill was no good for jumping but around the corner, on the same mountain actually but around the corner, on a north facing slope was a more suitable place. The only thing was it had a rock ledge up at the top of it that was in the way. I had worked for Mr. Penrose up on the Pikes Peak Auto Highway and I went to his office and told him we needed an air compressor to operate a rock drill and some dynamite and a bulldozer-tractor to shoot this ledge off and clean it up and make a jumping hill out of it. He asked me if I'd take care of it and I said, "Sure, I'll look after it and I'll run the things." So he loaned them to us." It was a Friday and I went over and loaded them on a track car and fastened them down and the train took them up that night and side-tracked them right there close to where the ranch was. Some of us, members of the Silver Spruce Ski Club, hauled the bulldozer up the site and then on Saturday and Sunday for two or three weeks went up and worked cleaning off and shooting off this hillside making a jumping place which was pretty good at that time. Then some of the members went to work clearing timber and building a twenty-five foot tower.[119]

Silver Spruce Ski Club members, men and women, practiced their jumping at Edlowe. Then, in 1929–30, they went back to Genesee—this time to compete. Some took home prizes. Their success in competition and at home caused the club, and its treasury, to grow. "With the advice of Thor Groswold, a tireless promoter and ski manufacturer who once lived in Colorado Springs and later in Denver, the new funds were used to expand the facilities to include 60-, 120- and 170-foot jumps as well as a novice 40-foot jump, a toboggan hill and a new three-room cabin.[120]

In the years of plentiful snow, it was difficult for the ski club members, of whom there were up to one hundred now, to get to the new facilities. However, jumping and Nordic tournaments were held there for a few years. Then, the winters changed for a while, and snow was scarce. Also, skiing was evolving, and people were gravitating toward the new style called downhill, or Alpine, skiing.

The last year the club used the ski jump hill, the weather had changed and there was a dearth of snow. To hold their annually scheduled tournament, sanctioned by the U.S. Western Ski Association, members had to haul snow in on trucks from wherever they could find it: remaining drifts along a snow fence, up near Catamount Reservoir, etc. The trucked-in snow

had to then be hauled by hand in bushel baskets up the ski jump. It seems the lack of snow pretty much killed the club's enthusiasm for their jump hill and its location![121]

GLEN COVE

This ski area was just below Glen Cove in Teller County at 11,425 feet of elevation on the road to the top of Pikes Peak about a mile below timberline, according to Lawrie (GPS coordinates: 38°52′34″N, 105°4′22″W). The hill had been cleared in 1924 by Thor Groswold and Lars Haugen for a summer jumping competition, which a young Lewis Dalpes won; they were the early jumpers.

When Spencer Penrose let go of the lease of the highway leading to the top of Pikes Peak and his permit expired, the gate came down, and anybody and everybody could drive it. The skiers did just that and went up to Glen Cove. Also, they started the Pikes Peak Ski Club. The year was 1935, and Lawrie was president. "Our club joined Civilian Conservation Corps (CCC) workers in clearing off the hill and improved it for a new kind of skiing, skiing for pleasure. We cleared two new down-mountain trails: one very steep starting at Glen Cove and running one-half mile down through heavy timber, the other running from the upper cove to the lower."[122]

After about a year, he decided a rope tow was in order:

We got an old Whippet automobile chassis for a power plant…We bolted the two wheels together to put the tires on to make a V drive for our rope in order to have something to drive the thing. It was kind of makeshift but it worked pretty good. We soon found out that if we didn't keep the tires inflated the rope would get down between them and bind. And this old Whippet automobile, I don't suppose anyone even knew we had an automobile by that name, but we did.

The old Whippet didn't last very long. Then we went to a Model A Ford engine on the big hill and we got a Buick or two on a smaller hill and that's what we used for two or three years.[123]

Lawrie's grandson, Don Sanborn, and friends continue the story: "As it happens, this was the first rope tow built west of the Mississippi. The first chairlift in the world was built by the Union Pacific Railroad at Sun Valley

Barney McClean prepares to race while Thor Groswold (left) and another skier wait their turns. *Courtesy Grand County Historical Association, Hot Sulphur Springs, Colorado.*

Idaho at the same time and went into operation about a week ahead of the Pikes Peak rope tow."[124] Members of the club with some pull in city council invited the council up to the ski area and convinced it that they needed electricity. The council agreed and had electricity delivered to Glen Cove.

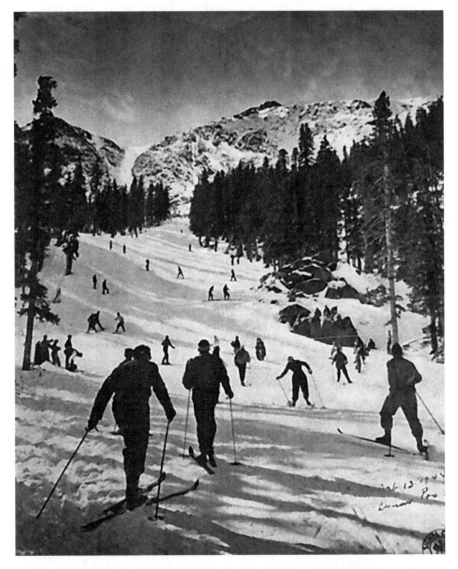

Members of the military ski at Glen Cove in the 1940s. *Photo courtesy Don Sanborn.*

Holly Sugar Corporation gave them an electric motor, so they replaced the gas-powered engines on the rope tows. A depreciation fund was set aside to keep the tows in shape. Also, the ski club had an all-risk insurance policy on the tow for $1,000, which cost the club $29.

Billboard advertises goods in ski pioneer Don Lawrie's ski shop. *Photo courtesy Don Sanborn.*

"With the Pikes Peak Highway now being maintained as part of the State of Colorado highway system, the club could call on the state to plow the road anytime it snowed. With free highway access and the new rope tows, the club grew quickly. The first annual ski tournament of the Pikes Peak Ski Club was held on February 20, 1937. Thirty skiers entered the tournament, which included slalom, downhill and ladies' slalom competitions."[125] The Colorado State Slalom and Ski Jumping Championships were held at Glen Cove on February 26, 1939, and the old jumping hill at Edlowe was pressed into service; it had never been completely abandoned. The fame of Pikes Peak and its skiing spread. In 1941, the *New York Post* wrote, "It is perhaps the most scenic ski course on the North American continent. A broad, steep river of glistening white, banked with the deep green-bronze of pine, spruce and fir. Above it and beyond it tower unscalable crags, gray, timeless, their jagged heads thrust high against a cobalt sky."

When World War II broke out, skiing effectively came to a halt in the Pikes Peak Region, as it did everywhere else, but the area stayed open somehow. Soon, the ski club turned Glen Cove over to the military, to Fort Carson and Peterson Field for their use.

In 1944, the first all-military ski meet in history was held. The meet was sponsored by the Colorado Springs Junior Chamber of Commerce and brought competitors from several military installations, including Camp Carson, Peterson Field, Camp Hale and others. Camp Hale, located between Red Cliff and Leadville, was the training facility for the 10th Mountain Division...The Signal Company of the 104th Division strung telephone wires from the top of the ski run to the finish line to aid in timing the race. Camp Hale's Toni Matt was crowned "Ski King" after taking top honors in the combined downhill and slalom races. The top nine places were taken by Camp Hale men. Life Magazine *and the Associated Press were in attendance to record the first military meet for the rest of the country to witness.*[126]

ELK PARK WINTER SPORTS AREA
(AKA PIKES PEAK)

In the late 1940s, local ski enthusiasts, including Lawrie, who had become the Pikes Peak Highway administrator, decided to find a new ski area that would be less windy. Riding in an army Weasel, they scouted the north side of Pikes Peak and found a north-facing slope they liked below Elk Park. The base of the area was about a mile downhill along the road from Glen Cove (GPS coordinates: 38°53′10″N, 105°4′9″W). The following describes what they had to do to make it ready for skiing:

The runs at the new "Elk Park Winter Sports Area" were cleared initially by the Pikes Peak Highway road crew when the crew could take time away from their normal duties. The work was finished by Lawrie with the aid of volunteers including Colorado College students and Fort Carson personnel. They spent most summer weekends working at the new area and sleeping in sleeping bags under a tree on Saturday nights. An old CCC building was moved to the base of the new area to act as a warming house, and kitchen facilities were constructed.[127]

Pikes Peak Ski Club gave the three rope tows, a total of 2,400 feet, to the City of Colorado Springs for Elk Park.

"The Pikes Peak Ski Corporation was formed as a nonprofit Corporation to finance improvements and the area opened for skiing in the early 1950's.

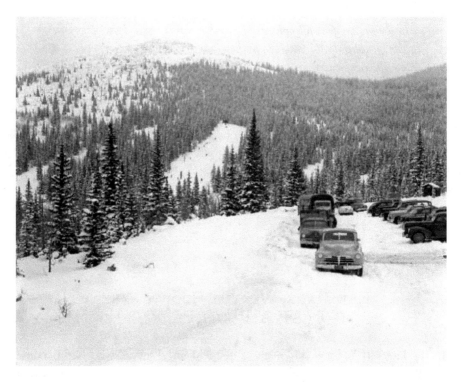

Cars await the return of their drivers at the Elk Park Ski Area in the 1940s. *Photo courtesy Don Sanborn.*

I was involved on the Board of Directors until the mid-60's when the area was sold, but we had a nice ski area for the people of Colorado Springs who skied there until 1984 when the area was closed…We jut wanted a nice pleasant area for the home folks, and that's what we had."[128]

Organizers tried to find a way to secure a chairlift for the area, but one effort after another failed. "A second small Poma lift was added on the beginner's hill; and the area operated with little change from 1960 through 1980, with the exception of the 1966/67 season when it was closed due, once again to, you guessed it, lack of snow."[129] Upgrades were made eventually and a double Poma chairlift was installed in the 1980s. However, the chair took skiers to higher terrain, where there was more wind. And, again, there were some bad seasons with little snow and financial troubles began. Elk Park had to close after the 1983–84 season. There is still a large parking area at the base and the runs and lift lines were still visible in 2014.

Holiday Hills

This area was separate from the continual development that started with the Silver Spruce Ski Club and ended at Elk Park. In 1962, Harlan and Kay Nimrod started the ski area for their sons on their private property between Edlowe and Catamount in a subdivision they made (GPS coordinates: 38°55'57"N, 105°5'4"W). Later, the Nimrods opened the area to the public on weekends. "The ski area operated until 1972 and often had 400 to 500 skier visits per weekend. Holiday Hills had a contract with the Air Force Academy to run a ski school for cadets. With a J-Bar, three rope tows, nine runs, and an A-frame house from which hot dogs and chili were sold, the ski area provided a nice family area for those wishing to learn to ski."[130] Tickets were $3.50 in 1965.

When the Nimrod boys grew up—and there were insurance increases and snowfall decreases—the area closed.

Tenderfoot Mountain

This area was about halfway between the ghost town of Gilette and Cripple Creek (GPS coordinates: 38°46'2"N, 105°8'55"W) and operated from 1948 into the 1950s.

A caption for two newspaper photos reads:

SKI CONDITIONS AT THEIR BEST—The Tenderfoot Mountain ski course near the historic mining town of Cripple Creek was formally opened to the public last Sunday. The area is about two miles out of the Gold Camp and just east of Colorado Highway 67. A T-bar and a rope tow are available at the course, which is owned and operated by Jess and Joe Vetter. Lessons are available to all those who wish instructions on Saturdays and Sunday. The choice Tenderfoot Hill location was chosen after a survey was made last summer by the experts of the Colorado Springs Zebulonnaire club, James R. Coulter, George Silvola, Pete Tyree and John Atkinson, Jr. About "two" feet of snow is reported on the course, although more fell last night. Ski conditions are perfect, according to all reports from the famous mining camp.[131]

A separate headline about the area reportedly said, "White Gold Strike on Tenderfoot Mountain!"

111

ColoradoSkiHistory.com reports that the area had one J-Bar, which was a Larchmont model 5LB2, and two rope tows. The website details:

The ski area was located in the heart of the Pikes Peak gold region. It was constructed by Cripple Creek Ski Club members, who selected the site and built the J-bar. The portable rope tow was used the first ski season because the J-bar was not totally finished, but was later kept to add more lift capacity. The area closed in the 1950's; the lack of snow and expert terrain probably contributed to its closure. The area's J-bar was moved to Monarch in 1956.[132]

RAINBOW VALLEY RANCH SKI AREA

The Colorado Skier Information Center on West Colfax Avenue published this information for the 1962–63 season:

Rainbow Valley Ranch Ski Area, year round mountain resort on western slope of Pikes Peak adjoining Pike National Forest. Located 32 miles west of Colorado Springs, via U.S. Highway 24 west to Divide, then south on State Highway 67 five miles [GPS coordinates: 38°51′34″N, 105°9′56″W]. *All winter sports. Rainbow Valley Ski Area offers one long sled tow (500 ft. vertical), 2 miles of trails plus two small tows for beginners and children. Skating on 3 beautiful lakes averaging 36-inch smooth ice, November through April; Curling, 2 sheets with all equipment inaugurating special course, sleds available. Hockey, exhibition games and practice. Sleigh rides. Horseback riding on magnificent mountain trails, over 300 sunny days per year. The St. Moritz of America. Rates include three delicious meals, all winter sports, riding, entertainment: $18 and up per person daily. Gold Miners' Bar, evening entertainment, ski movies, daily planned activities. Free transportation from Colorado Springs. Special group rates. Weekend winter sports parties (Wednesday through Sunday) include ski trips to Breckenridge and Monarch. Pine paneled units and cottages with fireplaces, private bath and terrace. Phone Betty Fritts for reservations, Colorado Springs Mulberry 7-9516, or write Divide, Colorado.*[133]

Skiers have gone back to the roots of skiing at Pikes Peak and ski the old Glen Cove runs. *Powder Ghost Towns* by Peter Bronski indicates how you can

do that if you're so inclined: "Today, Pikes Peak remains the domain of hearty backcountry skiers, returning the mountain to its earliest form of skiing. Winter descents of the old Pikes Peak ski area, and spring descents of the cirque walls above Glen Cove—South Bowl, Funnel, Rock Garden, and Cornice—pay homage to the lift-served skiing of early pioneers and more recent downhillers alike."[134]

Many of those people you've read about here, the hardworking and bold ski enthusiasts who established skiing in the Pikes Peak Region, have been inducted into the Colorado Ski and Snowboard Hall of Fame,[135] including Don Lawrie, Thor Groswold and Lewis Dalpes.

9

El Paso County

European Skiing in Colorado

Like the Wind, Like an Electric Flash, Like the Speed of Light Itself, is Skiing
—Gazette Telegraph *headline, 1935*

When a second wave of skiing came to the United States and to Colorado in the 1930s, it caught up the one ski area in El Paso County and carried it along.

Alpine skiing began in Arlberg, Austria. It had been developed in the Alps and was also called downhill skiing. The equipment was different: skis were shorter, and skiers used two poles. The attire was different: trendy, upscale, fashionable. And the skiing itself changed: athletes turned when they were coming down a hill instead of flying straight down.

"These differences signified more than a change in athletic practice," wrote Gilbert Coleman. "Alpine skiing brought visions of the Alps and a cosmopolitan social world to America in the 1920s and 1930s in the form of European ski instructors."[136] The folksy, community-oriented skiing of the Scandinavian tradesmen started to go by the board as skiing became an activity of the elites at posh resorts. Many resorts remained family oriented at first, and some would always be that way. But they would gradually be pushed out by the larger, more-expensive venues because Alpine skiing was market-driven. It supplied a segment of the population with what it demanded, which was a different type of skiing.

SKI BROADMOOR

Most areas, such as those at Pikes Peak, started with Nordic or cross-country skiing and ski jumping and then gravitated to downhill as it became popular. But a grand hotel in Colorado Springs known as the Broadmoor skipped the first types of skiing and went straight to the new kind. Not only that—it got the benefit of a brand-new invention to make Alpine skiing possible for their patrons, snowmaking.

Ski Broadmoor was located on Cheyenne Mountain, just to the west of the Broadmoor (GPS coordinates: 38°45'50"N, 104°50'56"W). The hotel put out a description of what skiing used to be like there:

> *For many years, quality ski instruction and programs for young and old were offered at Ski Broadmoor. The small ski area, designed to complement The Broadmoor Hotel's winter sports program, officially opened in 1959. It was a pioneer of innovation, boasting lights for night skiing and a $200,000 snow making machine known as the "Phenomenal Snowman", the first of its kind west of the Mississippi.*
>
> *The slope dipped 3,000 feet with a vertical drop of 600 feet. A double chair lift carried 600 people an hour up to the top. There was an excellent ski school for everyone from toddlers to adults with certified instructors. In addition, there was the Broadmoor Ski Club, Senior Racing Club and a Junior Racing Club for youngsters who advanced from white hat status to red hat, then blue hat and finally black. These teams and skiers went on to race in national competitions.*
>
> *As Colorado ski law changed, insurance escalated, and the "Phenomenal Snowman" fought a changing climate that brought Chinook winds and drastic changes in temperature each season, it became hard to maintain economic viability. Ski Broadmoor closed as an operation of the hotel in 1986, when the city of Colorado Springs leased the area. The city ran the area for two seasons until Vail leased it in 1988. Vail never made a profit and closed the area in 1991. Cog Land & Development Company retained the land and has developed a gated housing development on the property.*

The addition of skiing to the Broadmoor's offerings must have pleased Spencer Penrose, who "built the Broadmoor hotel in 1918, the Pikes Peak Highway in 1916, and the Cheyenne Mountain Zoo in 1926."[137] The entrepreneur also supported skiing at Pikes Peak early on. In 1938, he donated $300 to the Pikes Peak Ski Club so they could renovate a cabin for

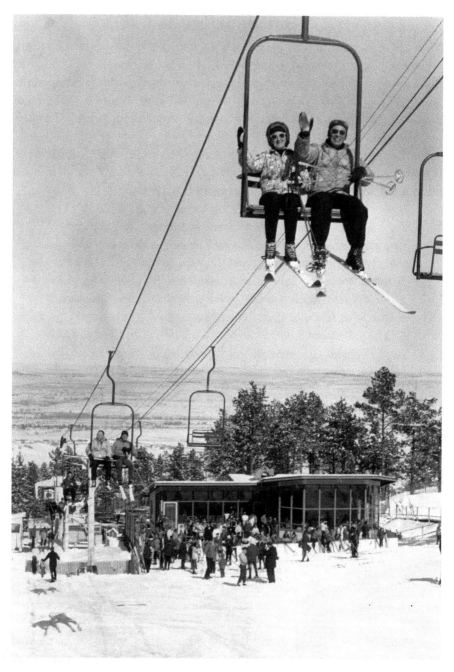

Skiers ride the chairlift at Ski Broadmoor. *Courtesy Broadmoor Hotel archives.*

Racer flies down a slalom course at Ski Broadmoor. *Courtesy Broadmoor Hotel archives.*

the club's use. Also, he allowed the club to use equipment to build the ski jump at Edlowe and seems to have encouraged his guests to ski at Glen Cove.

Lefty MacDonald sold the innovative snowmaking equipment he'd invented at Magic Mountain to Ski Broadmoor. "A Larchmont snowmaking machine installed at Ski Broadmoor insures excellent ski conditions regardless of the normal snowfall," wrote Colorado Ski Country USA in the 1963–64 edition of the *Manual of Colorado Skiing and Winter Sports.* "The machine is capable of laying down an inch of snow an hour over a 40,000 square foot area when temperatures are below freezing. Ski Broadmoor is floodlighted for night skiing and operates daily from 10:00 a.m. to 5:30 p.m. and from 7:00 p.m. to 10:00 p.m., except for Sunday nights, and all day Monday."[138]

ColoradoSkiHistory.com lists the lifts as having been a double chairlift (Riblet) and a tow with the capacity of six hundred people per hour.[139]

10

ℒarimer County

Good Times and Community Skiing

The movie camera proves that the Colorado Mountain Club men, who are enjoying their annual winter outing in the Rocky Mountain National Park, are a hardy lot and that they take to skis like a duck to water, when it caught them skiing off of the roof of one of the cabins at Fern Lake clad only in their shoes, so that they might keep their skis on their feet.
—Estes Park Trail, *1924*

S kiing in Larimer County reached its pinnacle when Hidden Valley was in operation. People came from all around to ski, from Fort Collins, Denver and neighboring states. More importantly, perhaps, it was a beloved part of the Estes Park community; the children and youth grew up having fun on that hill.

It did not spring up from nothing, however. Folks had been having fun on skis in Rocky Mountain National Park for a few years before the area was developed.

The whole thing began, as in many other parts of Colorado, when Estes Park was settled by men who logged and set up sawmills, such as Abner Sprague and Freelan Stanley. They, and their workers, had the ski culture. And lots of snow fell in the mountains around the parks. It was natural that skiing would be going on there, and it did. It came to the higher elevations, and it came to valleys a little lower down—and the people from the plains, including students and professors at Aggies (CSU), came up to it. Students even came up for summer skiing.

The Colorado Mountain Club (CMC) came along and started cross-country skiing outings in the area, followed by winter carnivals. It had hired an

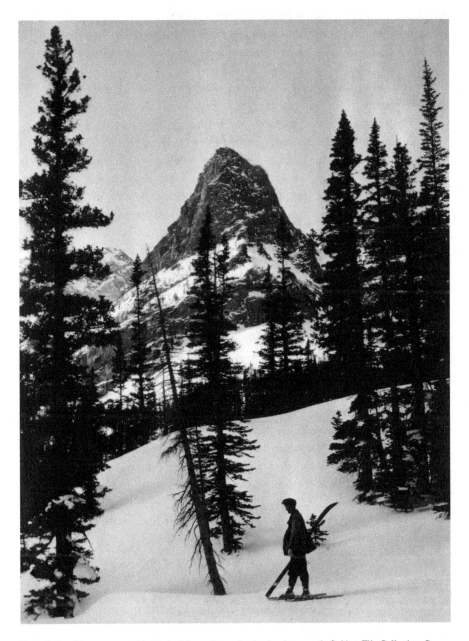

Fern Lake skier pauses with Little Matterhorn in the background. *Subject File Collection, Scan #10042911, History Colorado, Denver, Colorado.*

instructor—a step ahead of its time because most of the European instructor types did not come to the States until the 1930s—named Mr. Tshudin, and he talked up skiing to CMC members and the Estes Park community.

> *It is about twenty years ago that my country, Switzerland, started into winter sports, which were brought to us from the Northern countries. We did not realize at that time the increase of the sport would be so tremendous and that my country would become in a few years the heart of European winter tournaments. Small villages up in the mountains which had in the old times only a few lodges, are today the most marvelous winter resorts, with railway connections and hotels, the latter furnished with all improvements to satisfy our guests, who are coming from every part of the world.*
>
> *Colorado, and especially Estes-Rocky Mountain National Park, has a big chance to become the same sort of winter resort we have in Switzerland. I may say that in many ways your conditions are better. I have been here only a few days, but I can surely feel the charm of your Rockies, which are in their kind as beautiful as my Swiss Alps.*
>
> *Many people in your community have worked hard to get winter sport started here and I believe that within a few years their labors will be rewarded with golden fruit. Naturally it is necessary that you work together, and that everyone help boost your nice plans. If you do so you will succeed in having a second St. Moritz in your own region.*
>
> *I am very much obliged to your committee, which is making possible my stay with you for the season to help arrange the different kinds of sports and teach you how to do and enjoy winter sports. I hope that I will have plenty of work and I count it a great pleasure to help you in every possible way.*[140]

The ski jumping craze of the 1910s and 1920s had ignited the fire, and Estes Park residents put on tournaments and got in on it.

OLD MAN MOUNTAIN

In 1921, the town held its first tournament ever, and this is where they held the jumping contest. The *Estes Park Trail* reported, "Sunday afternoon at two o'clock the big jumping events of the tournament were scheduled on the Old Man Mountain course a mile above the village on the Fall River road,

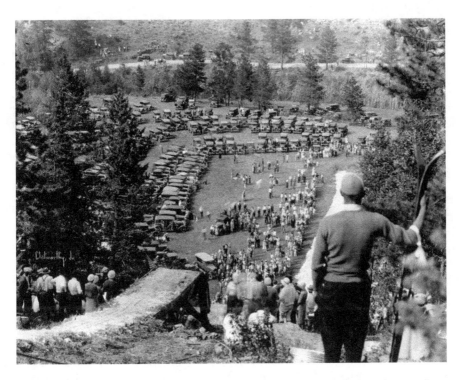

A crowd gathers for summer ski jumping at Old Man Mountain in Estes Park. *Courtesy Estes Park Museum #1974016011.*

just above Elkhorn Lodge. A good crowd was present to witness the events and many jumpers from Denver and other towns were present to take part in them."[141]

It was a great deal of work to keep a jumping hill in shape and available for practice and tournaments. It was reported that local youngsters interested in ski jumping spent a large share of one weekend shoveling literally tons of snow onto the Old Man Mountain Ski Jump, getting it ready for use. They also constructed a snow fence by the courses. It was the first time in several years that the Old Man Mountain ski jump had been in condition to use.

One article described the tournaments that continued through the 1940s—and more work for local youth:

Crawford and Wren Enter Ski Tourney

A classy contingent of the best skiers in Colorado—led by Gordon Wren, Olympic star, and Marvin Crawford, national junior champion,

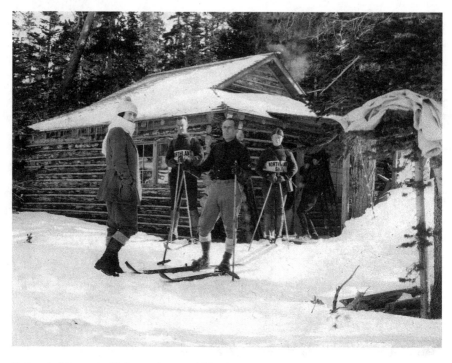

Colorado Mountain Club members and friends enjoy a winter outing at Fern Lake. *Courtesy Woody Smith, Colorado Mountain Club archives.*

will be in Estes Park Saturday and Sunday for the classic combined and junior jumpingmeet.

Officers of the sponsoring Estes Park Winter Sports Club estimated today that more than 75 contestants will be here to take part in the cross country events at Hidden Valley on Saturday, and the jumping meet at Old Man Mountain beginning at one o'clock Sunday afternoon.

Several hundred spectators are expected to flock into Estes Park for the meet here, especially for the Sunday events. In order to help defray expenses, the Winter Sports Club is selling tickets Sunday.

The jumping slope at Old Man Mountain, just a mile and a half above the Village on the Fall River Road, is in good condition. However, club members have been working for the past several nights, hauling snow for the "run off" area . . . The Old Man Mountain jump is rated at 140 feet, but longer jumps have been made there. The takeoff runway has been moved about 15 yards up the mountain.[142]

You can still see the mountain to the south of Fall River Road (GPS coordinates: 40°22'53"N, 105°32'33"W). It's an iconic landmark, but the former jump is on private property.

FERN LAKE

This area, which is in Rocky Mountain National Park above Moraine Park (GPS coordinates: 40°20'9"N, 105°40'38"W), was a favorite for CMC members to ski in the early twentieth century. Sometimes they would ski at Odessa Lake too.

"Beginning in 1916 the Colorado Mountain Club made a tradition of holding an annual winter outing, usually at the Fern Lake Lodge in Rocky Mountain National Park," wrote Woody Smith. "Activities included the 'new' sports of cross country skiing, snowshoeing, ski jumping, and in limited form, downhill or alpine skiing."[143]

The Fern Lake Lodge was a big part of the draw to the area. Dr. William Workman from Kansas built it in 1910 with local timber on the shores of the lake.

In 1922, the Winter Carnival ran for ten days. The following report appeared in the *Estes Park Trail* in March 1922:

> *Today, Friday, March 10th, the Colorado Mountain Club members, who will participate in the Club's winter sports carnival at Fern Lake, will arrive and take lunch at the Brinwood.*
>
> *Estes Park has no desire to feel exclusive and is pleased to have these boosters for the Rocky Mountain region with us to enjoy for ten days the splendid opportunities for winter sports presented at Fern Lake.*
>
> *This is the sixth annual event held at Fern Lake by the Colorado Mountain Club and it is rapidly growing in popularity among the membership. The snow has never been in better condition than at present and the ski and toboggan courses are everything that could be desired of them. Ranger Stephens has restored telephone communication to the Lodge so that those who attend may keep in touch with the outside world.*
>
> *The trail to Fern Lake Lodge is said to have never been in better condition for rapid travelling. From the end of the road to the Pool it will be possible to travel on the creek, which gives an easy grade for this distance.*

Miss Sally Vaille skis at Fern Lake. *Courtesy Woody Smith, Colorado Mountain Club archives.*

Skiers pose with a forest ranger (next to last on left) at Chambers Lake. *Courtesy Colorado State University archives.*

Proprietor Byerly has made every possible arrangement for the comfort of those attending and "Red" Kearns will supervise the good eats for the hungry guests. The man-in-the-moon will be full during the event and will do his best to shed his radiant glory nightly over the whole scene of the affair and moonlight sports will be indulged in.

The first party to arrive will be made up of fifty-six persons who are glad to be alive and to enjoy the pleasures of God's great out-doors.[144]

Sadly, the good times did not go on forever. CMC members looked to other places for winter sport. "February 1935 was the last Winter Outing at Fern Lake, victim of changing times."[145]

The lodge changed owners a few times. In 1976, after it was vandalized, the NPS burned it down.

If you're so inclined, you can ski the country around Fern Lake today. Peter Bronski tells you how in his book about backcountry skiing, *Powder Ghost Towns.*

CHAMBERS LAKE

Another popular area for CMC members to ski—this one starting in 1938—was located on the east side of Cameron Pass about five miles before the top, or two miles past Chambers Lake. Because of the change in the highway over the years, we were not able to locate this ski hill beyond any doubt. Our best guess is near a turnout where the old and new highways intersect (GPS coordinates: 40°34'52"N, 105°51'11"W). Peter Bronski tells the story in *Powder Ghost Towns*:

> *In that first season, skiers and members of the Colorado Mountain Club cut test runs, checked snow depths, and obtained funding for a new ski area. The USFS and CCC took over cutting more ski trails. Meanwhile, the Cameron Pass Ski Club converted an old cabin at the base of the area into a shelter house for skiers and ski patrol members. Hot lunches were served on weekends. The area had two primary runs, each with 300 feet of vertical drop: one a quarter mile long, the other three-eighths of a mile long.*[146]

The ski club grew and elongated its lift in search of new terrain, but the good times there lasted only until the early 1950s.

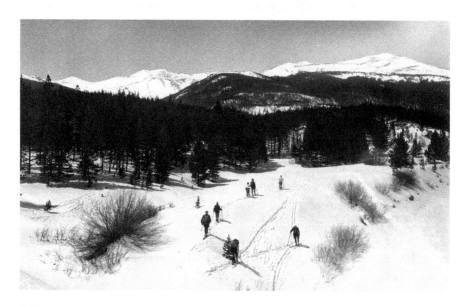

Skiers go cross country skiing at Chambers Lake. *Courtesy Colorado State University archives.*

LEYDMAN HILL

According to ColoradoSkiHistory.com this was an Estes Park jumping hill. It was located in town behind the hospital during the 1950s.

DAVIS HILL

Estes Park residents enjoyed this hill in the middle of their town, according to ColoradoSkiHistory.com. It operated in the 1920s and 1930s and may have had the first night skiing in the state. Also, this may have been where the aforementioned Mr. Tschudin from Switzerland taught skiing.

A ticket was simple at the ski area in Rist Canyon. *Courtesy of the Fort Collins Museum of Discovery, Accession #2008.021.0001.*

Rist Canyon

A lost area was being newly discovered, or remembered, in 2014 (thanks to USFS personnel and their friends for the information from a lost ski area forum that was being shared by e-mail). The area was on private land and operated in the 1970s. Solid data indicate that it was about halfway up Rist Canyon, just east of the Rist Canyon picnic ground, west of the town of Bellevue (GPS coordinates: 40°38′33″N, 105°18′22″W). Its base was at 7,150 feet of elevation, and the vertical drop was one hundred to two hundred feet. It seems that it had one rope tow.[147] Much of this area was burned in the High Park fire in 2012, but the ski slope is still visible.

Hidden Valley

The mother of all ski areas in Larimer County was Hidden Valley (GPS coordinates: 40°23′36″N,105°39′22″W).

The land on which Hidden Valley came to be located seemed to be preparing for its existence for years ahead of time. There was logging on it, which led to blowdown of stands of lodgepole pine when winds kicked up and sometimes a natural fire or two. Brian Brown and friends sum up the result in Brown's documentary about the ski area (www.skihiddenvalleyfilm. org): "Blowdown, logging, and fires all led to large swaths and openings through the trees in Lower Hidden Valley…Which led to what? Skiing, of course!"[148] The documentary gives a comprehensive look at Hidden Valley, its heyday, people and closure, much more than you'll read about here.

In the late '20s, the National Park Service started building Trail Ridge Road in Rocky Mountain National Park. Equipment and cabins for workers were kept in the area that would become the parking lot at Hidden Valley; it was a sheltered valley back away from where the road was being built. Even at that time, locals were learning to ski there.

Monte Hurt said, "Back then, Jack Moomaw started taking the kids up to Hidden Valley and teaching them how to ski. They literally skied the old horse trails. You know, the horse trails make 90-degree turns. So, you ski to that corner and stop, kick turn and come back. If you were really good, you could make the biggest, tightest turn around that corner, but it was literally a complete 90-degree turn and you were going back the other way. It was pretty wild, and you went across the fall line, not down the fall line. And,

Moomaw ended up cutting runs for the ski area, including the 'Suicide/ RIS' run that dropped 1,000 [feet] in a measured mile. The 1934 National Down Mountain Ski Race went down Suicide. Local team member Junior Duncan, a Moomaw protégé, won the race."[149] Moomaw was a park ranger for the NPS.

World War II affected skiers and skiing in Estes Park, as it did everywhere and everyone else. One resident, who was a skier and a ski jumper, went to fight with the Tenth Mountain Division. He trained at Camp Hale near Leadville, the story of which will feature much more in the second lost areas book.

George Hurt was wounded during the war. As he recovered, he focused on a dream: "There I was in Fizsimmons Hospital. So, I got discharged from the Army in September then. My big objective was to start a ski area at Hidden Valley, and that's what I came home and was able to accomplish."[150] He built all the equipment himself, including the tow, and then he built another tow and hauled it up above the other one. He improved things year after year and instructed those who wanted to learn how to ski. It was a family affair: Mrs. Hurt ran the concession stand and sold tickets, and their sons grew up on the slope and helped as the years went by, especially with shoveling snow. The tow was basically lodgepole pines with a pulley on them, and it had to be mobile because Hurt had to take it out every year at the behest of the National Park Service.

NPS really kind of seemed to be driving things all along. In 1920, Captain L.C. Way, superintendent of the park, wrote a column for *Estes Park Trail Talk*:

> *The laying out of ski runs and toboggan slides in connection with the winter sports program occupies much of our time at present. The great success achieved each winter, insures the permanency of the venture and opens up new realms of pleasure. The Rocky Mountain National Park affords opportunities unexcelled for winter sports. In and near the village of Estes Park golf links are in use, while in the mountains the snow lies to a depth of 3 to 39 feet, over which, with snow shoes or skis, one may roam at will. No need to follow the beaten path.*[151]

His comments presaged the conflicts of the future. And as the years went by and NPS evolved, so did the relationship with Estes Park residents.

While Hurt was running lift-served skiing, NPS decided it wanted more sophisticated equipment, so it put someone besides Hurt in charge of Hidden

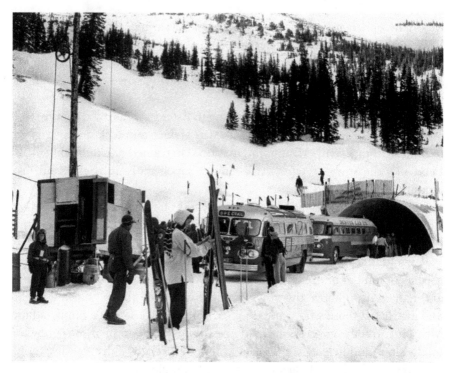

The National Park Service and area organizers used a Quonset hut to create a tunnel on the road between upper and lower Hidden Valley. It was removed at the end of the season. *Courtesy Estes Park Museum.*

Valley: Ted James Sr. Eventually, a chairlift was put in, which was reputed to be the coldest, windiest ride you could imagine. They later took the chairlift down. Before and after the chairlift, they ran buses to take skiers to the upper part of the mountain.

Brian Brown said:

The National Park Service in the '70s was quite different than it was in the '50s, when it actually encouraged the massive outlay of funds and resources from a concessionaire to create a man-made recreational use, like a lift-serviced ski area, within its borders. By the '70s, a paradigm-shift into wilderness areas had swept through the NPS. There was also quite a bit of leeway given individual parks' leadership. Unlike say Yellowstone or Yosemite, Rocky Mountain NP was definitely bent on removing human-made improvements within the Park (like historic ranches and

lodges), and Hidden Valley was no exception. The 1976 Master Plan essentially sunseted the developed ski area, clicking the stopwatch on the proverbial "beginning of the end" for HV. Snow making was also a big concern. If you watched my film, there's quite a bit of detail in there about the divisiveness over stream flows, water allocation and greenback fish counts. Ski areas east of the Divide have long struggled with less snow, more wind and colder mean temperatures. While a few still survive (Eldora, Loveland and Snowy Range), none would be able to combat low-snow years without adequate snowmaking, and the NPS was limiting HVs.[152]

After years of great skiing for the community—during which many, many residents participated as ski patrol, instructors and devoted skiers—NPS decided it was time for the park to go. There were a few reasons: environmentalism (snowmaking used a lot of water from Hidden Valley Creek), expenses for keeping Trail Ridge Road open, and so on. The park and recreation district in the city sided with the NPS for its own reasons, including the public's desire for a focus on golf, and they helped to shut the area down.

The closure impacted the community of Estes Park very negatively. Brown said, "Estes Park gravely suffered, in my opinion, with the closing of the ski area. Local schools lost a treasured resource for outdoor activity in the long winter months, and merchants and hoteliers lost seasonal business. It also created tensions between the town's residents and the park service (and the local rec district) that will probably remain for generations."[153]

It had been a pretty great area. Colorado Ski Country USA gave details about Hidden Valley in 1963–64:

Area offers two T-bar mechanical lifts, 1000 capacity per hour each, one in Upper Hidden Valley, 2300 ft. in length; one in Lower Hidden Valley, 1500 ft. in length. Beginners' rope tows 400 ft. in length. Buses transport skiers and equipment from Lower Hidden Valley to Upper Hidden Valley. New intermediate ski trails between Upper and Lower Hidden Valley.[154]

The Colorado Visitors' Bureau also wrote about it:

Hidden Valley is actually two distinct areas—with uniquely interesting advantages. Highlight is National Park Service shelter house, with spectacular mountain view, intriguing displays and ranger-conducted

lectures. Upper Hidden Valley is 4½ miles from lower Hidden Valley, where parking lot, shelter, house and restaurant are located. Lift tickets are good at both areas…Slopes maintained by tracked vehicles and crew. Ski Patrol. Medical personnel and ambulance at area.[155]

However, only the voices of the people can convey what Estes Park residents lost when they lost Hidden Valley. You can hear them in the Brown documentary. Still, there is a silver lining: locals are skiing HV runs the way they did in the 1920s, as backcountry skiers. You can read about how to do that in Peter Bronski's book *Powder Ghost Towns*.

11

Gilpin County

Dreamers Making It Happen

Apex was rich in snow, and photos of the old town show two-story outhouses, built to reduce the necessary shoveling.
—Colorado Gambler, *2000.*

This tiny county, home to Black Hawk and Central City, has always attracted big dreamers: miners, opera singers, gamblers. In the 1930s and 1940s, dreamers of a different kind came to it. They were ski enthusiasts who dreamed up a ski area to capitalize on the riches in snow, not gold or silver, and they called it by the name of the ghost town where it would be located.

APEX

Bill Goe, Ralph Balent and Donald and Horace Hix had an idea that took hold of them in the 1930s when they were Boy Scouts in Denver: they would build and operate a ski area at old Apex. "The boys first experienced skiing with used equipment and they fell in love," according to the *Nugget*, newsletter of the Gilpin Historical Society. "But, World War II interrupted their grand plans for Apex for a short while."[156]

Funny, because World War I had interrupted best laid plans for the town of Apex. It had been a pretty sophisticated little town with a main street called Gilpin, a newspaper called the *Pine Cone* and two hotels, the Apex

The Rock Creek rope tow wasn't fancy. *Courtesy U.S. Forest Service.*

and the Pine Creek. There was also a social center for dancing and church called Pioneer Hall. Some of the mines thereabout produced pretty well. "Authors agree the best mine was the Mackey; it produced such prodigious amounts that a mill was built adjacent to it to process its ore," according to Linda Jones, writing for the *Colorado Gambler.*[157] Other mines were called the Schultz Wonder, Yellow Medicine, Annie Mascot, Wetstein, Jersey City, Rooster, TipTop and the Evergreen. Then, the U.S. government banned gold mining during the war, which was the beginning of the end for the town, and it descended into ghost status as the population left.

Through the years of World War II, the four friends corresponded. "Although they were widely separated, serving in the Navy, the Army Corps of Engineers, the Army Air Force, and the tank corps, they corresponded enthusiastically about their ski area."[158] When they were all discharged in 1946, they set about making it a reality, starting with surveying possible locations.

They chose the north face of Idaho Mountain, purchased eight mining claims and got permission from the U.S. Forest Service for a towline. In the end, they had a narrow strip of land in the Arapahoe National Forest. The government charged them $10 a year for use of its land.[159] They bought a

134

half track in Salt Lake City from war surplus to clear stumps. This they had to drive back in shifts because they couldn't turn it off, and that took three days. "In order to supply the rope for the ski tow the men again turned to war surplus, paying $333.07 for 1,667 pounds of 1½[-inch] diameter manila rope. War surplus also provided the men with forty-eight wool blankets and a generator/engine combination for pulling the ski tow."[160]

Some say they purchased an old miner's club and renovated it into a five-bedroom lodge with a fireplace and a kitchen. Others say it was the old Pine Creek Hotel. Anyway, they spent the fall of 1947 getting the place ready for the opening, and they did it. "After months of hard work...the Apex Ski Company opened for business on December 7, 1947."[161] And their big claim to fame was that the area was just forty-seven miles away from Denver.

The charge for using the tow was one dollar. Eventually, there were two that ran only on weekends. Sometimes, skiers would just walk up and ski down.

Apex eventually went the way of the ghost town. Problems that were encountered included insurance company demands that changes be made to the tow for safety and that landing areas be leveled. Also a railing was required for the tow. The expenses were too much for a struggling company. They tried in 1951 to make a little profit by bringing in slot machines for people to use when they weren't skiing, but it wasn't enough.

Apex went out of business in the early 1950s. The ski area was located just west of town up County Road 4N (GPS coordinates: 39°51'49"N, 105°34'30"W).

12

Boulder County

Chautauqua, Clubs and Competitions

They were emphatic that a course could be laid out on Cowbell Hill that would be equal at least of any in the world, and with its comparative accessibility would eventually become the skiing center of the world.
—Longmont Ledger, *1923*

In 1988, the *Boulder Daily Camera* created a summary of stories it had done on skiing and ski files in the newspaper's library. It gave the files to the Boulder County Public Library. The document gives an interesting overview of how skiing developed in the county. Details about lost ski areas pop out in it. Also, it functions as a rough timeline of skiing in the county from 1926 to 1980.

The summary also shows how the coverage in local newspapers affected the development and the demise of areas. If there was an editor who supported skiing, the coverage tended to be positive; if not, it focused on the negatives. Sometimes, newspaper articles revealed the outlandish claims ski boosters made to communities. Other times, it showed how ski culture was changing and that people were going west to the big areas. Also, the coverage was probably colored by whether the editor felt like a part of the community or not. The cultural change of the '60s and '70s may have taken Boulder away from the community feeling it once had; it's the only place we ran across where theft of machinery from a ski hill was reported.

Skiers walk into Rock Creek. *Courtesy U.S. Forest Service.*

Allenspark

Allenspark, located high in the mountains northwest of Boulder, was an early ski destination for jumping, training, competitions and recreation and, over time, included two small ski courses or jumping hills near town and a bigger ski area nearby in the Rock Creek drainage. According to Peter Bronski in *Powder Ghost Towns*, the earliest hill was started in or at the edge of town in 1918 by Lars Haugen and Hans Hansen and dubbed the Haugen Slide. Four years later, the newly formed Allenspark Ski Club created a longer ski run and jumping hill farther west in the Willow Creek drainage. A rope tow was added in 1939 and the hill was used

137

into the 1950s. The Rock Creek area was opened in 1946 and continued operation through 1952. Some of the history is a bit confusing as various sources referred to all three areas as Allenspark at times and the term Haugen's Hill may have been used for both hills near town. We were able to find clear evidence of a ski course on a 1953 aerial photograph located on the ridge south of and a little west of town (GPS coordinates: 40°11′33″N, 105°31′52″W). This is likely the Willow Creek hill that was used into the 1950s. The site is still visible today. The Rock Creek area was located on County Road 107 about two and a half miles south of town (GPS coordinates: 40°9′40″N, 105°32′12″W) on national forest land, and although it included multiple runs and lifts, the timber has grown back in and it is barely visible today.

The ski course/jumping hill at Willow Creek was popular for competitions during the 1920s and 1930s and hosted tournaments as part of the U.S. Western Ski Association. The hill was also used for training and Winter Sports Festivals by the Aggies (CSU) ski team during the 1940s.

The following article from the *Longmont Ledger* gives an idea of what the goings on were at the area in the early days:

Ski Tournament Success:
Events Came Off as Per Schedule Despite Blizzard Which Came Up

Over 500 people braved the threatening weather and drove to Allenspark to witness the Second Annual Tournament of the Allenspark Ski Club and the general opinion was that they were well paid for their trouble. Just as the contestants lined up at 1:30 for a photograph a snow storm came up that for a time threatened to stop the program. It lasted only about half an hour, after which the weather kept improving all the afternoon.

The jumping of the international amateurs, Lars Haugen, Hans Hansen and C.L. Hopkins, was all that could be desired on a new course. Haugen's leap of 101 feet was the best seen in this part of the country, while the loop-the-loop by Hansen, and Hopkins' spectacular riding were revelations to those who thought ski riding was a form of children's amusement.

Haugen, we were glad to observe, had thrown off his jinx and was able to ride without falling, which had bothered in the last two tournaments. Hansen demonstrated how it was possible for him to jump the 235 feet he made at Revelstoke, B.C. Two other thrills for the onlookers came from the toboggan jumps made by Ed Marquand and Guy Mattern of Denver.

Skier has good form on the rope tow at Allenspark. *Carnegie Branch Library for Local History.*

Goldie Miller and Glenn Porter made a very pretty exhibition twin jump. Longmount [sic] can be proud of the good showing made by its beginners in taking the prizes they did.

The winning of prizes in a ski tournament is determined by points. A point is counted for each foot jumped, from which is subtracted various numbers for falls, for putting down a hand or both and for general form in jumping and riding.[162]

The Rock Creek Ski Area, begun in 1946 with two rope tows, was envisioned to provide a larger recreational ski area with multiple runs and lifts that would attract skiers from Boulder, Fort Collins and Denver. The summary described a story from the *Longmont Times-Call* that said the new ski courses at Allenspark were popular with winter sportsmen and that USFS people thought the area was destined to be one of the most popular in Colorado. Bill Hottel, a former Tenth Mountain Division soldier, was managing the area at the time. The area closed in March 1952 due to the

same struggles of funding and maintenance that plagued many a ski area. To read more about the history of the Rock Creek Ski Area, and how to ski there today, see *Powder Ghost Towns* by Peter Bronski.

NEDERLAND (CARDINAL HILL)

The summary by the Boulder newspaper mentioned in an entry for November 9, 1948, that the new lift at Nederland would be completed in a month. Harris A. Thompson, whose nickname seems to have been Tommy, and some students were "working on the installation near the old Cardinal townsite." It opened on a Saturday at the end of December 1948 with "1,400 feet of rope two in two sections and six feet of snow." The area is referred to alternately as Nederland or Cardinal Hill. According to another entry, it was three miles west of Nederland on Caribou Road, but we were not able to discern any ski runs or evidence of a lift line from among the many mining works, roads and power lines visible on old aerial photographs. Our best estimate is that the ski area was somewhere close to the Cardinal town site marked on topographic maps (approximate GPS coordinates: 39°58'9"N, 105°33'2"W).

A *Daily Camera* article of December 6, 1951, talked up the ski area at Nederland, saying it was the closest major ski area to Boulder at twenty-two miles from the city or forty minutes of driving time. "Thompson also said there would be no waiting in tow lines, and that more trails than ever before would be open. Food prices are reasonable and a heated shelter is provided.

"Thompson also extended an invitation to several ski fans to help out at the Nederland area. He said that four skiers to work Saturday are needed to help install the rope and trim trees. They can earn season tow tickets, he said. A tow operator for Saturdays and Sundays throughout the season, a married couple to take over the food concession, and skiers with first aid experience for the ski patrol are also needed. Full information may be secured by calling Thompson at 1202-W evenings."[163]

CHAUTAUQUA MESA

The summary gives a look at how, by working together, the Boulder community created this hometown area, which was located at Chautauqua Park near the southwest edge of the city (approximate GPS waypoints: 39°59'48"N, 105°17'12"W). Also, it shows how outside forces put the nail in the coffin of the area, including newspaper editors; when the support waned, it died.

At the beginning, in October 1947, Bert Street, owner of a sporting goods store, called for people to help clear rocks west of Chautauqua for a ski area. By January of the next year, a children's jump had been created on a mesa nearby. Perhaps this was how the area became known as Chautauqua Mesa. The Junior Ski Championship was to be held there in February; Felix Dunbar was going to give free instruction. Apparently organizers wanted to have as many entrants as possible because they said it wasn't necessary to be a good skier to enter the competition.

The newspaper called the area a ski run outlet for the local fans and said it was being well used because of good snowfall. They reported that work had started on an 860-foot rope tow that could serve 1,200 skiers per hour. The tow was planned by Thompson, a faculty member at CU in the electrical engineering department. The same good snow, however, was making work of installing poles, etc., more difficult.[164]

In May 1948, Thompson, who also ran the tow at Nederland, offered a ski tow plan for the mesa to the city council. He wanted permission to erect a six-hundred- to seven-hundred-foot rope tow at Sixth and Baseline Streets. In October of the same year, the Jaycees, which was a service club, sponsored "Operation Big Push" to move rocks off Chautauqua Mesa. "Strong backs needed," they said. This effort went on through November with some verbal arm-twisting and few volunteers responding. December brought news. "Chautauqua Mesa's face is lifted to permit skiing and ski jumping. Areas cleared of rocks; three jumps finished; 800-foot rope tow to be installed." It was to be ready by January.

The new year brought an exciting event on the mesa. "Ski jumping exhibition slated for Chautauqua Sunday. Demonstrations to be given on largest of jumps being developed. Barney McLean and Gordy Wren, members of the 1948 Olympic team, among those invited. Steve Bradley and Roland Chivers will give instruction to youngsters." More than one thousand spectators came out to witness the exhibition.

Alfred Allen, recreation chairman, wrote an open forum in praise of work on the ski mesa by interested parties, including the CU Ski Club, Jaycees and individuals.

Sometimes a girl needed help with her boot when skiing Chatauqua Mesa. *Carnegie Branch Library for Local History.*

Work began again on the "city ski jump" when spring and summer rolled around. Bulldozers were used and smoothing was needed. The work went on through the fall.

In January 1950, ski classes were to be offered on the mesa, but they were canceled because of lack of snow. Interest in Chautauqua Mesa seemed to fade; fewer stories were written about it while more were written about other

areas, which skiers could reach by train. A meeting was announced. "Skiers of all ages invited to attend an open meeting tonight. Session at Armory on University Avenue set for discussion of Chautauqua ski tow operation and ski instruction here and at Winter Park."

News on Chautauqua Mesa was reported sporadically through 1961: Mary Jean Hobbs, sixteen, broke her ankle skiing there; Jaycees offered to run the tow; service discontinued because of vandalism and lack of snow; tow was run on January 26 from 6:00 to 9:00 p.m.

In March 1963, it was reported that the Jaycees were set to operate the ski tow again, but they found motor parts stolen. "After long wait for good snow storm, the entire ignition system for the motor and the field telephones used in operation had been stolen."

It was a sad ending to a community hill.

ROGERS PARK

In 1926, said the summary, Thor Groswold took honors at a ski meet on a Sunday on the Rogers course and seven hundred people attended an intermountain tournament held under auspices of the Boulder Ski Club. Thor Groswold of Denver won the first such event "on the Rogers Park course at Eckel's Lodge in Boulder County." This was twelve miles up Boulder Canyon. Our best estimate of the location was on the slope south of the highway across from an open area that may have been the original Rogers Park, now part of a larger open-space park (approximate GPS coordinates: 39°58'16"N, 105°28'14"W).

Stephen Bradley, coach of the CU ski team, wrote an article for the *Daily Camera* that gave "hints" about how to use the ski jump after the area was dedicated in 1948. It gives an idea of how a person went about learning to jump. The following is from the actual article:

> *By normal standards the jump is a small one and was purposely made that way, in order that it might be used by the growing children of Boulder as well as the students at the University. The hill actually is two ski jumps in one. On one side is a very small take-off for advanced beginners in the sport and next to it is a larger take-off for the more capable jumpers. The small take-off is approximately one foot high and any young jumper can ride it with complete safety, providing his skiing is advanced to the point where he*

can ski down landing competently. It is assumed, of course, that no person would attempt to jump from the larger take-off until he had thoroughly mastered the small one.

Experience in the conducting of successful ski jumps elsewhere compels me to indicate a standard procedure which is based upon common sense. Ski jumps, contrary to the sensationalism fostered by the news reels whose only intent seems to be to present their sport in a most dangerous bloodthirsty and utterly false manner, are not dangerous in the least providing the people who use them exercise a minimum of common sense.

First, a person interested in trying out such a jump should ski down the landing hill enough times to feel thoroughly confident that he could ski the hill with ease. Once that is done the second move should be to try out the very small take-off. This should be used many times until the budding jumper has built up skill and confidence. Thirdly, he should continue to use the small take-off taking a little bit more speed each time by starting farther up the hill. Finally, after a great deal of jumping from the small take-off which builds up a fund of experience coupled with necessary self-confidence, the jumper is ready to try the larger jump. In doing this he should not take full speed, but should start lower down the hill than is normal and ride off the jump several times from there to acquaint himself with the features of the larger jump. There is no substitute for experience and constant practice and therefore a skier should not attempt to do more than he is capable of merely because he has more confidence than he has common sense.

Finally, and no less important is the condition of the ski hill itself. Every aspiring jumper must remember that he is partially responsible for keeping a ski jump in proper and safe condition. If a person falls down he generally makes some sort of hole. Sportsmanship in golf compels the golfer to replace his divots; in ski jumping he should fill up the holes that he makes. A hill should always be tramped down with skis several times during a normal afternoon of practice and every jumper should see to it that the hill is left in good condition for the jumpers who will use it on the following day. If these very simple rules are observed then no one need have any fear; if they are not then a careless attitude on the part of the ski jumper will endanger not only himself but all the others too. Of course, this is true about everything we do in life, anyway.[165]

Another coach of the Colorado Buffs in another era rebuilt the Rogers Park jump for training. The *Boulder Daily Camera* covered that in the 1960s. This article was instructive about how jumping hills were located and how

they were built—and makes one marvel that people built ski hills in the early twentieth century before bulldozers:

Buffs Building 49-Meter Jump At Rogers Park

By the end of the week Colorado University will have one of the top ski jumps in the nation.

This was the comment of Bob Beattie, Buff ski mentor and coach of America's 1964 Olympic Alpine ski team, last week as he reviewed preliminary work at the university's newest athletic facility.

49-Meter Jump

The facility is a 49-meter—170 foot—ski jump located in Rogers Park, a scant 10 miles from Boulder. Bulldozers and dynamite have cut a 38-foot, sharply pitched swath down through the trees on the north eastern exposure of a hill above the park where the Boulder Elks hold their traditional picnic.

CU was given permission to install the jump by the Platt-Rogers estate, owners of the land. It will be known as the Platt-Rogers Memorial ski jump.

Members of the Buff ski team this week are hand finishing the course with shovels and rakes.

Friday it will be in shape, ready for the season's first snowfall.

The finishing will be such, according to Beattie, that the jump can be put to use with a snowpack of only eight inches. The approach boasts nearly a one-to-one foot drop and the runout a 34-degree pitch. It will outrank in size most collegiate jumps in America.

While located at a comparatively low elevation, Beattie foresees little difficulty from the standpoint of snow because the run gets only about an hour of sunshine per day during the winter and is protected from the wind. "We have been watching the area for several years now and we know it has a long snow-pack season," the coach said.

Advantages of New Jump

In addition to having one of the best jumps in the nation, Beattie is enthusiastic over the new facility for two other reasons.

First, the Platt-Rogers jump combined with the new Eldora Ski area, will put CU skiers on the slopes quicker and more frequently. Formerly, the team did its training at Winter Park, 87 miles from Boulder. Now it will train at Eldora, 21 miles from the campus, and at the new jump only 10 miles away.

Second, the jump will provide a "focal point" for developing a junior ski jump program in the area. Smaller jumps, Beattie thinks, will be built elsewhere in the vicinity of Boulder as the big jump whets the appetite of youngsters for jumping.

Two jump meets already are lined up for the new facility in the 1962–63 season. Jumping competition for the CU intercollegiate meet, Feb. 16 and 17, and a special open jump meet, yet to be scheduled, will both be held there.[166]

The article featured two photographs with captions. One read, "STEEP-PITCHED JUMP—Jack Ostrander, bulldozer operator, speaks with authority when it comes to describing the nearly one-to-one pitch of CU's new jump. Ostrander said that on at least two occasions his giant earthmover skidded for 50 feet down the drop before he was able to bring it under control. Hand finishing of the jump by members of the Buff ski team will be completed this week."

13

Weld County

A Shark with Sunglasses

A funny thing happened this past weekend. With hardly any snow on the ground and only five miles from Greeley people were having fun, fun, fun and skiing up a storm.
—Greeley Journal, *1971*

Nobody would expect a ski area to spring up close to Greeley—to be precise, ten minutes away from downtown or one mile north of U.S. Highway 34 on Weld County Road 25. But, that's exactly what happened. With partner Clyde Davis, who worked in real estate, Mayor Dick Perchlik and his wife Sylvia, created a beginner ski hill on a sandstone bluff overlooking the Cache la Poudre River.

Skiers enjoy the slope at Sharktooth.
Carnegie Branch Library for Local History.

Sharktooth

They named it Sharktooth because they found sharks teeth as they built it. The area opened in 1971 with a logo of a shark wearing a ski hat and sunglasses. Reportedly, Mayor Perchlik presented Governor John Love with the first season pass prior to the grand opening, and there was a ribbon cutting and evening torchlight parade with other dignitaries present on December 18. Hours of operation for the hill were 10:00 a.m.–4:30 p.m. and 6:30–10:30 p.m.[167]

Sylvia Perchlik spoke to the *Windsor Tribune* in 2004. Her husband had passed away from cancer at age sixty in 1988, a year after the ski area closed. "He started doing it as a community service so that the average kid who couldn't afford to go to the mountains could learn what skiing was. He thought it was such a great sport."[168] She said that her husband would be up at nights making snow because the temperature had to be below freezing and that he put a lot of other sweat equity into it, presumably with Davis. "He totally changed the contour of part of the hill. There was a little pony lift. They were metal bars that hanged out from a cable, and you just hung onto the metal bar."

In a 1985 interview with *Greeley Style Magazine*, Perchlik said, "When we first opened, I envisioned Sharktooth as a place where people would ski who could not afford to go elsewhere."[169] Of course, this was in the best tradition of the small community hills to the west; ranchers and others created most of them so local kids could ski. "The terrain, usually covered in artificial snow, offered a 1000 foot run, five minute lift lines via rope tow, a ski jump, and tubing. A warming lodge was on site as well as ski patrol." Also, there was instruction on site and night skiing. "A daily admission pass in 1971 was $3.50."

Rises in the cost of insurance and a decision to annex land in the vicinity by the City of Greeley ended the days of the only ski hill near Greeley. In 2004, Windsor developer Martin Lind was planning to start another area called Pelican Run. We haven't discovered what happened to that idea.

If you hike the Poudre Trail, you may be able to look over to the bluffs and see the former runs, reports the history museum.[170] The entrance to the private home that now occupies the base area has a fantastic gate depicting the Sharktooth logo, which you can see along the county road (GPS coordinates: 40°26′13″N, 104°50′4″W).

14

Park County

Mail Carriers and Mercury

My snowshoes were of the Norway style, from nine to eleven feet in length, and ran well when the snow was just right, but very heavy when they gathered snow. I carried a pole to jar the sticking snow off.
—Reverend John L. Dyer, 1889

Skis were for getting around in the nineteenth century in Park County, as elsewhere, especially in winters that brought a lot of snow.

The story is told that, during the terrible winter of 1898–99, a man named Jess Oakley skied from a small mining community to Como for the mail. Linda Bjorkland wrote of his venture:

> *Thirty and forty foot drifts covered the tops of buildings and entrances were reached through elaborately shoveled tunnels through the snow. He set off on snowshoes heading towards Como. When he got to the top of Boreas Pass, he was craving a hot cup of coffee, but couldn't find a sign of any buildings, let alone the railroad station house. Finally he noticed a wisp of smoke trickling out of a chimney six inches below the snow. A further search revealed steps dug into the snow leading to a house twenty feet below. Jess had his coffee, then made it to Como and back with the mail and several newspapers, which he promptly sold for $1 each.*[171]

About the same time, Park County's famous preacher Reverend Dyer, who is known as Father Dyer, was looking for work:

About midwinter I found myself without means, and so sought work, but could get none unless I would work on Sundays, which was out of the question, except to prevent actual starvation.

In the forepart of February, a man came to me who had the contract to carry the mail from Buckskin Joe to Cache Creek by Oro, California Gulch, a distance of thirty-seven miles. He had carried it as long as he could on a mule. It was once a week, and he offered me eighteen dollars a week to carry it on snowshoes. I thought at once: "I can preach about as often as I have been doing, and am not obliged to go on Sunday." So I took the mail, and crossed the Mosquito Range every week, and preached three times a week.[172]

Dyer lived in Buckskin Joe, above Alma, during this time. Recreational skiing wasn't top on the list of priorities in the county, but there were a couple areas over the years.

NEW MERCURY SKI COURSE

This area was located at Alma (GPS coordinates: 39°17'18"N, 106°4'15"W). It had two runs, one that was six hundred feet and another that was eight hundred, as well as a seven-hundred-foot rope tow with a two-hundred-foot rise in elevation. There were no jumps or shelters, according to John McMillin.[173]

Erik Swanson, owner of Fairplay Antique and Art Gallery, remembered an adventure at Mercury:

I skied and we tobogganed a lot because we were little kids. Skiing was still kind of scary. At that point in time, there was a wonderful two-story log house still standing there...Mrs. Van Houten had fixed that up, and she would sell us hot chocolate. This must have been 1952, '53. I was ten or twelve or fourteen.

The rope tow was more fun riding it up than...they had some kind of old car motor that would pull it up and down...Harold Tubbs, who was a Public Service man, he got it kinda going. Anyway, you'd grab the rope in front and in back, but we were little and didn't weigh very much, and when there was a dip, we just would go flying. So, it really was more fun to ride the tow up than anything down. I remember one Sunday, for some reason, I got clear up to the top and I was looking down there. I didn't

know what to do; I was scared to death, and I didn't know how to stop. I think that I was one of the only kids my age that went from the very top to the very bottom. I was going hell bent for election![174]

One of the authors, Peter Boddie, lived in Alma and cross-country skied the area one moonlit night in about 1978. "There were a number of aspens that had grown in, but not so many that you couldn't ski the slope, provided you were good at making telemark turns. Near the bottom, I found a pole with a pulley, confirming the local rumor that Mercury Hill had once been a ski area."

INDIAN MOUNTAIN

This area was about ten miles southeast of Jefferson in South Park, and it operated now and then during the years of 1972–88, not continuously (GPS coordinates: 39°14'47"N, 105°43'30"W). It had a Poma lift, a 573-foot drop, two surface lifts, five trails and a beautiful view from the top. The Indian Mountain Ski Area was built to serve the residents of the surrounding subdivision community and, hopefully, to attract skiers from Colorado Springs and Denver, as well as other towns around South Park. Unfortunately, the area suffered from a lack of consistent snow and it could never divert enough skiers from going on to Breckenridge for a bigger mountain and better snow.

Clear Creek County

Roads Less Traveled and Family Areas

This will make excellent winter sports available in less than two hours' drive from Denver. The ski courses are the highest in the world.
—*C.E. Learned, 1933*

The ribbon of Interstate 70 cuts through Clear Creek County on its way to central and western Colorado. Along its trajectory through the foothills and in the high mountains beyond, ski enthusiasts and developers planted ski areas and resorts. Some of them grew close to towns that existed before I-70; others sprouted towns after.

The areas that are open today are very close to the highway and easily accessible from it. That's good for the skiers from the Denver Metro Area, mostly, except for the ever-increasing traffic congestion. Skiers who took other roads to lost areas close to the city now take the interstate farther to large areas, and they seem to know Clear Creek County only as the place where they sit in lines of cars every weekend or for the stop for pizza in Idaho Springs. Maybe Denver skiers didn't know how good they had it when they could take different roads or the Ski Train to different areas for a little fun on weekends.

Anyway, Clear Creek is more than the I-70 corridor, more than a traffic jam. And though it leads into other mountains, it had its own ski assets, including Squaw Pass, which is now operating as a private ski area.

Authors for the Historical Society of Idaho Springs wrote, "Opportunities to gather together and have fun were always eagerly

sought after by early residents. The emphasis was on enjoying nature and companionship. Almost all small-town entertainment and activity was self-generated."[175]

Lincoln Mountain Ski Jump

Skiers leave I-70 to drive to Empire along U.S. Highway 40. One of the first places residents had a good time was on Lincoln Mountain west of Empire and east of Berthoud Pass at a hill (GPS coordinates: 39°45'25"N, 105°42'10"W) near the old Glen Arbor Lodge. The good times were preceded by some hard work. "During the early part of the twentieth century, ski-jumping was a popular sport throughout the county. Near Empire, skiers cleared a course on Lincoln Mountain west of Glen Arbor Lodge and built a jump."[176]

The Glen Arbor Lodge, which is now separated from the jump by Guanella reservoir, is part of the Guanella family ranch. Paul Guanella worked for Clear Creek County as a road supervisor and county commissioner and Guanella Pass was named for him. Guests stayed at the ranch, which had been the Lindstrom Brewery. "Paul Guanella added a sleeping wing in 1914 to accommodate the many tourists who stayed with the Lindstrom-Guanella family. In the 1933–4 season there were 76 skiers. In the 1935–6 season, the number of winter guests went up to 318."[177]

St. Mary's Glacier

When skiers leave I-70 and head north on Fall River Road, they're headed to a place where skiing at the glacier was part of the great fun of the 1920s, in both winter and summer. A Fourth of July ski tournament became an annual event there, starting in 1923, according to Peter Bronski, author of *Powder Ghost Towns*. He gives backcountry skiers information on how to ski there today.

The glacier is located northwest of Idaho Springs above Silver Lake and Fox Mountain (GPS coordinates: 39°50'10"N, 105°38'50"W).

Bronski wrote, "St. Mary's Glacier is home to some of the earliest recreational skiing in Colorado. The permanent, year-round snowfield

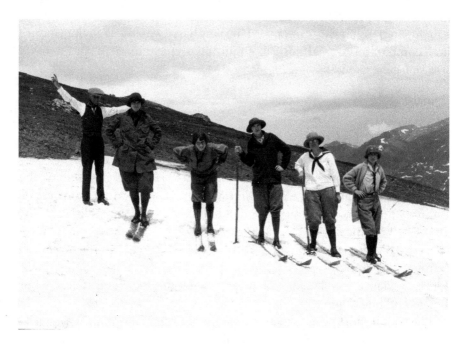

Girls just wanted to have fun with a little summer skiing. *Courtesy Colorado State University archives.*

provided a ready-made venue for the fast-growing sport. By the early 1920s, St. Mary's was a regular destination for Denver-based ski outings."[178]

A ski area opened south of the glacier and Silver Lake in Anchor Gulch. That was in the 1950s. It became known as Ski St. Mary's (GPS coordinates: 39°49′30″N, 105°38′45″W).

An article in the business section of the *Denver Post* reported on the sale of the area after it had been the Silver Lake Ski Area and Inn. "The purchasing group...obtained the 240-acre property with beginner and intermediate slopes, a T-bar tow and two wire-rope lifts in addition to the Silver Lake Inn...Silver Mountain is intended to be a low-cost, family-oriented ski area and will be one of the closest to the Denver Metropolitan Area...The lodge was built in the 1940s and the present ski-lift equipment was put into use in the 1950s." Investors planned to add a three-thousand-foot chairlift and expand to a total of five miles of trails. It did not pan out.

A plan was in the works to make the area into a snowboard terrain park, but that didn't work out either.

Brad Chamberlin said that Michael Coors bought the place and planned a ski area, but there was a backlash from the public about the plans. So it

remains in some kind of purgatory. There was a Stideli T-bar, and there were a couple rope tows, kind of homemade.[179]

BERTHOUD PASS

This was the name of one of the great ski areas off the I-70 corridor, and it was the name of a pass through the mountains. Skiing there wouldn't have been possible without the creation, and the improvement, of the road to the top of the pass. We placed it in Clear Creek County because early on most people came from Denver to ski or stayed in lodges near Empire. The county line straddles the top of the pass, and people skied on both sides of the highway, on both sides of the Divide, and in two counties, although the lifts were technically on the Grand County side (GPS coordinates: 39°47'53"N, 105°46'38"W).

"In 1920, as a push to build new roads swept the nation, the route over Berthoud Pass was incorporated into a planned coast to coast highway that stretched from New York City to San Francisco," wrote Woody Smith for the Colorado Mountain Club. "First called the Midland Trail Auto Road, then the Victory Highway, and by the late 1930s, US 40, the road over Berthoud Pass became an important link between east and west." In 1930, the route was widened and paved. It opened for year-round traffic in 1931.

"But local skiers had a different advantage in mind. You could drive to the top of the pass and ski down. Races, slalom, and jumping events were organized and drew hundreds of spectators. The CMC fanned the flames of the new fad by showing ski movies at least twice a month during ski season."[180]

The U.S. Forest Service strived to connect West Portal skiing and Berthoud Pass after that. With the Civilian Conservation Corps, they built a trail and a cabin, the First Creek Cabin, above West Portal and below Berthoud Pass on the west side. Cooper Creek may have been part of that effort too.

Denver's George Cranmer, the same man who had spied Carl Howelsen on the streets of Denver after the blizzard of 1913 and asked to be taught skiing, boosted the possibilities on Berthoud Pass in 1935. He was the manager of Denver Parks at the time. The mountain club seemed to agree. "In 1936, CMC ran a 'Ski-Bus' to and from Berthoud Pass—roundtrip $1.75. The bus also ferried skiers from the bottom for 15–25 cents."[181]

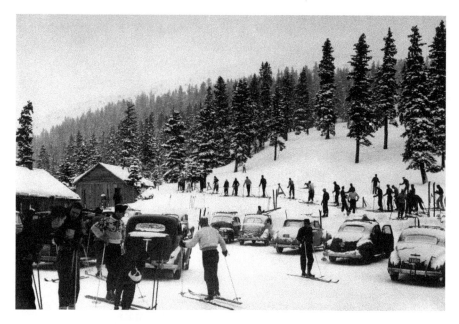

Berthoud Pass Ski Area was a popular place. *Courtesy U.S. Forest Service.*

Jack and Nancy Tipton ski at Berthoud Pass. *Courtesy Nancy Tipton.*

By 1937, Berthoud had its first rope tow going, reportedly with a V8 motor donated by Denver Ford dealers. ColoradoSkiHistory.com tells the story of Berthoud in the 1940s:

> *After World War II, the U.S. Forest Service (USFS) issued a permit to operate the ski area, which was now under that department's jurisdiction. A group of people from three prominent families in the Denver area became the owners of the ski area: the Grants, the Shafroths and the Tolls. Each family held 30% of the company, called Berthoud Pass Lodge, Inc., and the remaining 10% was owned by Sam Huntington. Huntington was a miner from Idaho Springs. The Grants, Shafroths, Tolls and Huntington owned the area from 1946 to 1972.*
>
> *The venture enjoyed success from the very beginning. In 1946, Berthoud hosted 30,000 of the 100,000 skier days recorded for the state of Colorado. Berthoud was always popular, since it was one of the closest areas to Denver (57 miles), easy to reach and already very well-known.*[182]

Berthoud Pass Ski Area became the place to be and be seen while skiing. Jack and Nancy Tipton made trips up from Denver to Berthoud to ski around that time. "They had a nice little lodge there," Nancy said and added that she tried the rope tow and couldn't hold on, so she never took the rope tow again. One time, she sat outside drinking a glass of wine with friends at the lodge and got a third-degree burn on her face; they didn't use sunscreen in those days. "It was just awful...and I had to stay home for awhile."[183] A pleasanter memory of Nancy's is taking lessons from an instructor named Merrill Hastings, who later became the editor of *Ski Magazine*. Ski style was improvised. Nancy said, "We wore baggy pants, and there weren't any places that sold ski equipment; there wasn't such a thing back then. I wore my sister-in-law's...snow pants. They were just baggy pants. We didn't wear pants much back then anyway."

In 1947, a double chairlift, which had been dreamed up by Huntington and designed by Denver engineer Bob Herron, began operating. The years passed and Berthoud kept going. The 1963–64 edition of the Colorado Ski Country USA manual read, "Berthoud Pass, the family ski area, 57 miles west of Denver on top of the Rockies, where U.S. Highway 40 crosses the Continental Divide, in Arapahoe National Forest...features 14 runs...slopes and runs maintained exclusively for beginners and intermediate. Also, spectacular ski trails for experts. Famous twin-chairlift is 2200 ft. long with 685 vertical rise and carries 480 skiers an hour. New T-bar 1750 ft. long with 525 ft. rise and 650 per hour capacity serves novice and intermediate

Women ride the double chairlift at Berthoud. *Courtesy U.S. Forest Service.*

trails."[184] Lifts operated daily and costs were $0.50 for a single ride on the chairlift, $3.00 for a daily ticket, $12.50 for a book of five tickets and $22.50 for two books. The ski school at the area was under the direction of Carl C. Gammill, and ski patrol served the area.

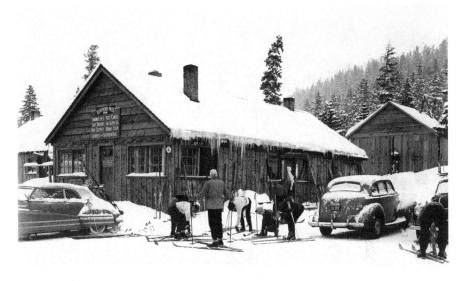

Skiers adjust their equipment at the old Berthoud Pass ski lodge. *Courtesy U.S. Forest Service.*

An article in *Empire Magazine*, written by Lois Barr, told the story of a new owner and what he planned to do with Berthoud. This was in 1977.

Formerly a weekend area, Berthoud recently was purchased by Clarence (Ike) Garst, 27, who this season plans to offer skiing on a daily basis.

Situated on both sides of the highway, Berthoud is one of the state's oldest ski areas…Altogether, Berthoud has 16 trails, most of them for intermediate skiers, the longest being almost a mile in length. However, there is enough advanced skiing, down such runs as the Trough and Stillman's Folly, to stand one's hair on end. The Trough was recently renamed "The Plunge" by Garst, who was unaware of the infamous run by the same name at Telluride.

The new owner also has laid out a beginners area near the base of the chairlift…Garst prides himself on offering the lowest daily lift ticket in the state—$6.50 per day for adults and $4.50 for children. Foot passengers also can ride the chair in the winter for $2.

Because Berthoud's altitude is so high (the chairlift rises to 12,015 feet), the area can open early in the season on good, natural snow. In the past, there has even been skiing on Labor Day. Berthoud normally receives some 360 inches of snow a year.[185]

Who's going to make it to the top? Skiers ride the rope tow at Berthoud. *Courtesy U.S. Forest Service.*

Garst was the first to allow snowboarders to ride the lift when that sport broke on the skiing scene.

But it's tough to run a ski area and Berthoud seemed to be running back to its roots as a river will go back to an old channel, if it can. The ski area shut down in the 2000–01 season after multiple difficulties, financial and otherwise. In 2005, the last vestige of the old ski area was removed by the USFS. *Denver Post* reporter Jason Blevins wrote about the last sad moments for Berthoud Pass and posted his story online June 13, 2005:

Berthoud Pass Ski Lodge Torn Down

Snow dusted the venerable Berthoud Pass ski lodge Friday, the last flakes that will ever fall on the creaking old dame of Colorado ski lodges.

That day demolition crews razed the 30,000-square-foot lodge that sheltered skiers at Colorado's oldest ski area for 56 years. The heydays of "The Pass" have passed.

"It was a huge piece of Colorado history that did not have to come down," said an irate Ike Garst, who in the 1980s ran the Berthoud Pass ski area with his wife, Lucy. They made history as the country's first resort owners to embrace snowboarders.

"It was a very viable operation when we had it, and it could have been again," Garst said. "This is a tragedy."[186]

Berthoud is not entirely dead and buried; it's very popular with backcountry skiers. Peter Bronski writes about how to ski it now in *Powder Ghost Towns.* Also, in 2014, there was a group for friends of Berthoud Pass.

Duck Lake

This area operated for a couple years near the south end of Duck Lake just up the valley from where Indianhead and Geneva Basin would be later. It had a surface lift. You can still see the cabins and a burned-out stone lodge that were part of the base area from the Guanella Pass Road (GPS coordinates: 39°34'38"N, 105°43'39"W).

Indianhead (Geneva Basin)

The 1963–64 edition of the Colorado Ski Country USA manual listed Indianhead Mountain (Guanella Basin):

Indianhead Ski Area is serviced by a 3200-foot-long double chairlift with a capacity of 900 skiers an hour and a 2000-foot long T-bar which can handle 1000 skiers every hour. Slopes and runs were designed by Sel Hannah, nationally known ski area consultant, and provide more than five miles of excellent skiing. There are grades, slopes and trails to suit the proficiency of any skier. Snow making equipment installed—Lower 300 ft. Vertical—1963. [187]

The manual notes that the area was ten miles north of Grant off U.S. Highway 285, or seventy-two miles from Denver, in Pike National Forest (GPS coordinates: 39°34'7"N, 105°43'36"W). Ski equipment could be rented in the Indianhead lodge, and there was a cafeteria serving food. The area operated every day from 9:00 a.m. to 4:00 p.m., and the cost of a full-day ticket was $4.00 on weekends, $3.50 on weekdays.

Today, the area can be hiked or skied as a backcountry adventure. Peter Bronski tells how in *Powder Ghost Towns*. But it did have a life as a lift-served area. Its story is much like those of Berthoud Pass or St. Mary's. It struggled to do well for many years and changed hands and names. First, it was Indianhead, then Geneva Basin and finally Alpenbach. In the end, a chair fell from the lift during an inspection, so it was closed. Sometime later, the U.S. Forest Service burned down the lodge to allow the area to return to its natural state.

For years leading up to that point, the ski area was a source of great joy and great heartbreak.

Ken Fosha, who owns and runs the Drowsy Water Ranch in Grand County now, worked at the area: "Geneva was just open weekends for a long time. I started as assistant manager when they went full time [and] did development work for them then, planning, working with the Forest Service. Everything went pretty smoothly then." [188] Fosha was a ski instructor there. He said of that job: "It was fun. Those type of areas build a lot of family drawing, a lot like what Granby Ranch has now." Geneva Basin was also responsible for building at least one family; Ken met his wife, Randy Sue, while skiing there.

There was an industrial accident at the beginning, a tragedy for the Guanella family, who helped build the area. Ed Guanella, Paul's son, was

killed while stringing cable for the Duck Lake chairlift. This was quite a blow to people in Georgetown and Empire. Nevertheless, the area was opened, and it served families for years.

The Whittington family, who lived in the Denver area, skied at Geneva Basin. Tom Whittington took his wife, Ann, and three daughters, Leticia "Tish," Lisa and Leah, skiing there. The family made time to talk with us about the experience.

Tom remembered, "When we started there, we got a family season pass for $125—the whole family for the whole year. I think we skied there two or three years, and they raised it $50 every year. They had one chairlift and one J-bar and one T-bar, and they serviced the area pretty good."

Tish said:

> They had one lift from base camp up to the top of the mountain; that was a chairlift. Then, from the chairlift, you went to the south, and you got to the easier...Sunlight or something...at the bottom of that hill, they had a T-bar. On the beginner hill, which wasn't at the top, you would go north from the lodge, and so it was isolated from the rest of the ski hill... They did have a bowl, and there was a side that was easy and then a side that was harder, steeper. So, there was a bowl and then there was the Tomahawk, which was narrow...where they had the T-bar over on the easy side, this T-bar was very particular. You had to know exactly how it went because there would be times when you would get really slow and you knew that you'd have to hold on, and then there was one place where it would lift up off the ground. You had to be sitting actually on it—you know how they say, let it pull you. No, not there! And, I can tell you, the alarm button was a few feet up from there.

Tom asked, "Didn't Leah get caught by it one time?"

Lisa said, "Leah got caught once...I fell off it a lot on that one particular bump. That bump was my nemesis."

Tish asked, "Wasn't it Geneva where you stayed on the lift and went back down?"

Lisa answered, "The very first time I rode the chairlift I didn't know how to get off, and Mom said, 'Just relax.' So, I sat back. Well, what else was I supposed to do? She said, 'Lisa, just relax!' And then she goes, 'No, no, no!' And by then it was too late; she was off, and I was halfway around...I broke my leg there, too."

"Yes, you did," Tish said.

"But, it was a great area to learn to ski, when we were all learning to ski," Tom said.

Tish added, "You couldn't beat the price. It was so near to town; I mean, it was great because it was so close to town."

Lisa remembered, "And you would always hope that Dad would want to stay the next day because the snow was really good, and then we'd stay at this little dive hotel down at the end of the road that was right next to the highway. And then we'd go back up on the mountain the next day and ski. And they had lockers, but everybody was kind of on the honor system. We'd bring our big things of food and set it in the lodge. Nobody would touch it because everybody would bring their own stuff. And they'd have all their stuff around, and then everybody would ski and just everybody knew."

"Mom would always make chili or stew, so we'd always have a hot lunch," Tish said. "But, the funniest story is our first drive up. So, we're in our ski clothes; it's all new to us—we'd been to a couple other ski areas, but not really skiing—and we're driving. We turn off at Grant and head down whatever the name of that road is, and pretty much it's just marsh land in a valley—there's no snow anywhere, the whole way. It's probably another 20 miles up to the ski area."

Lisa said, "And Tish kept looking at me, and Leah's in the middle."

"We're all saying, 'Dad, where's the snow?'"

"And Mom would say, 'Tom, did you take the right turn?'"

"And we started laughing because it was so funny, but he didn't laugh. He's thinking, 'Okay, I spent a whole $125 and there's no snow?'...but it was just in that little area."

Tom said, "Brown, brown, brown..."

"Well, they usually had pretty decent snow...the wind was horrible though."

The Whittingtons may have found out about Geneva Basin at the SNIAGRAB sale the Gart Brothers put on every year. After a while, the family went on over to Vail to ski, along with lots of other people; they went in on a condo with two other families. They heard about Geneva Basin closing years later.

"I was sorry to see it close up," Tom said.[189]

Skiers have been sorry to see many ski areas close up in Colorado's Front Range and northern mountains, but they sure were fun while they lasted.

Notes

INTRODUCTION

1. *Middle Park Times*, "Skisport."
2. Jenkins, "History of Skis."
3. *National Geographic* website.
4. Fay, *History of Skiing in Colorado*.
5. Coleman, *Ski Style*.
6. *Daily Journal*, "Telluride Should Have Ski Club."
7. *Estes Park Trail*, "Mr. Tschudin Sees Great Opportunity." The article above it on the page reveals that the same person was organizing classes for everyone in winter sports.
8. Fetcher, e-mail, expanding thoughts.
9. Leitner-Poma, http://leitner-poma.com/front-slider/leitner-poma-historical-timeline (accessed August 12, 2014).
10. Godfrey, *From Prairies to Peaks*, 213.
11. Ibid., 214.
12. Ibid., 238.
13. Ibid., 247.

CHAPTER 1

14. Betty Jo Woods, "Skiing at Grand Lake," GCHA 4, no. 1, 12. This seems to be one of the local newspaper articles from January 25, 1883, which were quoted in Cairns, *Grand Lake in the Olden Days.*

15. Jim Weir, "The Beginning of Skiing in Grand County," GCHA 4, no. 1, quoting Cairns, *Grand Lake in the Olden Days*, 12.

16. Nicklas, interview.

17. Ibid.

18. *Middle Park Times,* January 5, 1912, from GCHA 4, no. 1, 13.

19. Ibid., "Grand County's Winter Sports Carnival."

20. Ibid., "Judge Kennedy's Ride," January 30, 1914.

21. Moffat Railroad Museum website, accessed April 28, 2014.

22. Fetcher contribution to Colorado Ski History website, accessed May 11, 2014.

23. *Middle Park Times*, in GCHA 4, no. 1, 13.

24. Jim Weir, "Skiing at Hot Sulphur Springs," GCHA 4, no. 1, 14.

25. Ibid, page 15.

26. Nicklas, interview.

27. Weir, "Skiing at Hot Sulphur Springs," 19.

28. Ibid.

29. Fetcher, "Maggie's Hill," Colorado Ski History website, http://www.coloradoskihistory.com/lost/maggieshill.html (accessed June 27, 2014).

30. Armstrong, interview.

31. Nicklas, "Lost Ski Areas of Grand County."

32. Weir, "Skiing at Hot Sulphur Springs," 20, probably quoting the *Middle Park Times.*

33. Nicklas, "Lost Ski Areas of Grand County."

34. Weir, "Skiing at Hot Sulphur Springs," 20, quoting the *Middle Park Times.*

35. Fetcher, "Snow King Valley," Colorado Ski History website, http://www.coloradoskihistory.com/lost/snowkingvalley.html (accessed May 12, 2014).

36. Betty Jo Woods. "Skiing at Grand Lake," GCHJ, 4, no. 1.

37. Fetcher, "About Grand Lake Ski Areas."

38. Ibid.

39. Ibid.

40. Fetcher, "Ski Trail Mountain," Colorado Ski History website, http://www.coloradoskihistory.com/lost/SkiTrailMountain.html (accessed May 12, 2014).

41. Hamilton, *Images of America: Around Granby*, 99.

42. Fosha, personal interview.
43. Jim Wier, "Other Small Areas and Skiing After 1950," GCHA 4, no. 1, 55.
44. Fetcher "About Leland Jackson-Carmichael-Ouray Ranch Ski Hill."
45. Wier, "Other Small Areas," 55.
46. Fetcher, "Tabernash," Colorado Ski History website, http://www. coloradoskihistory.com/lost/tabernash.html (accessed July 20, 2014).
47. Jean Miller, "The Legacy," GCHA 4, no. 9.
48. Woody Smith, "Old Winter Haunts," quoting Nancy Crisp, "Denver Doings," *Trail & Timberline*, March 1928.
49. Jean Miller, "The Skiing's Great at—" GCHA 4, no. 9.
50. Colorado Ski Country USA, *Manual of Colorado Skiing*, Season 1963–1964.
51. Ibid., *Manual of Colorado Skiing*, Season 1962–1963.
52. Taussig, telephone interview.
53. Fetcher, "About Baker Mountain."
54. Fetcher "About Kremmling Hill."

CHAPTER 2

55. Howelsen, lecture.
56. McMillin, "Mountains of Memories."
57. Coleman, *Ski Style*, 34.
58. City of Denver, "National Ski Tournament."

CHAPTER 3

59. Howelsen, lecture.
60. "So Little Time For Such True Friends."
61. Steamboat Library, "Who Was Buddy Werner?" http://www.steamboatlibrary. org/about-us/history/who-was-buddy-werner (accessed July 15, 2014).
62. Colorado Sports Hall of Fame, "Gorden Wren," http://www. coloradosports.org/index.php/who-s-in-the-hall/inductees/item/237-gordon-wren (accessed July 15, 2014).
63. *Yampa Leader*, "Yampa Ski Club to Be Organized," Friday, October 20, 1916.

64. Fetcher, "Yampa Hill," Colorado Ski History website, http://www. coloradoskihistory.com/lost/yampahill.htm.
65. Herold and Bonnifield, interview.
66. Cork, "Where Skis Were Long and Lines Were Short."
67. Kisling, "Doggone It!"
68. Fetcher, personal interview.
69. Fetcher, "About Baker Hill."
70. Fetcher, personal interview.
71. Ibid.
72. Fetcher, "Clark Hill," Colorado Ski History website, http://www. coloradoskihistory.com/lost/clarkhill.html (accessed July 26, 2014).
73. Ibid., "Hospital Hill," Colorado Ski History website, http://www. coloradoskihistory.com/lost/hospitalhill.html (accessed July 26, 2014).
74. Ibid., "Holderness Ranch," Colorado Ski History website, http:// www.coloradoskihistory.com/lost/holdernessranch.html (accessed July 26, 2014).
75. Lay, "Ghost Turns: Lost Ski Areas Found."
76. Fetcher, "About Hospital Hill."
77. Saenger, interview.
78. Fetcher, " Steamboat Lake," Colorado Ski History website, http://www. coloradoskihistory.com/lost/steamboatlake.html (accessed July 28, 2014).
79. Steamboat Resort Real Estate website, accessed July 28, 2014.

Chapter 4

80. Bronski, *Powder Ghost Towns*.
81. Ibid.

Chapter 5

82. Fetcher, "Cathy Cisnar," Colorado Ski History website, http://www. coloradoskihistory.com/lost/cathycisnar.html (accessed July 26, 2014).
83. Lay, "Ghost Turns: Lost Ski Areas Found."
84. Vandelinder, "Cathy Cisar Hill."
85. Ibid.

CHAPTER 6

86. Kingery, *Colorado Mountain Club*, quoting Henry Buchtel in *Trail &
Timberline*, 1939.

87. Coleman, *Ski Style*, 39.

88. Ibid.

89. McMillin, "Mountains of Memories," 9.

90. "History of Winter Sports in Jefferson County," *City and Mountain Views*,
23.

91. McMillin, "Mountains of Memories," 9.

92. "History of Winter Sports in Jefferson County," *City and Mountain Views*,
23.

93. City of Denver, "National Ski Tournament."

94. Ibid.

95. Howelsen, lecture.

96. *Estes Park Trail*, "Combs Wins Ski Title."

97. McMillin, "Mountains of Memories," 9.

98. Ibid.

99. Hopkins, "Brief History."

100. Ibid.

101. McMillin, "Mountains of Memories," 10.

102. Ibid.

103. Kingery, *Colorado Mountain Club*.

104. Ibid.

105. Hopkins, "Brief History."

106. Ibid., 5.

107. McMillin, "Mountains of Memories," 11.

108. Fetcher, Colorado Ski History website (accessed July 17, 2014).

109. McMillin, "Mountains of Memories," 11.

110. Meyers, "Arapahoe East Coming Soon."

111. McMillin, "Mountains of Memories," 13.

112. Ibid.

113. Meyers, "Jump Back at Arapahoe."

114. Ibid.

CHAPTER 7

115. Advertisement, "Grand Fourth of July Celebration."

CHAPTER 8

116. Bronski, *Powder Ghost Towns.*
117. Sanborn, Kallaus and Ellis, "History of Skiing on Pikes Peak."
118. Taylor and Cott, *Century in the Shadow of Pikes Peak*, 28.
119. Ibid., 29.
120. Sanborn, Kallaus and Ellis, "History of Skiing on Pikes Peak," 2.
121. Ibid.
122. Taylor and Cott, *Century in the Shadow of Pikes Peak*, 50.
123. Ibid, 51–52.
124. Sanborn, Kallaus and Ellis, "History of Skiing on Pikes Peak," 4.
125. Ibid.
126. Ibid.
127. Sanborn, Kallaus and Ellis, "Skiing on Pikes Peak During and After World War II."
128. Taylor and Cott, *Century in the Shadow of Pikes Peak*, 76.
129. Ibid.
130. Ibid.
131. Caption under photographs attributed to Knutson-Bow, "Ski Conditions at Their Best."
132. Fetcher, Colorado Ski History website (accessed July 17, 2014).
133. Colorado Ski Information Center, *Manual of Colorado Skiing.*
134. Bronski, *Powder Ghost Towns*, 85.
135. Colorado Ski and Snowboard Museum Hall of Fame website, (accessed July 18, 2014).

CHAPTER 9

136. Coleman, *Ski Style.*
137. El Pomar, "Spencer Penrose (1865–1939)," http://www.elpomar.org/who-we-are/our-history/spencer-penrose (accessed 18 July 2014).
138. Colorado Ski Country USA. *Manual of Colorado Skiing*, Season 1963–1964.
139. Fetcher , Colorado Ski History website, accessed July 18, 2014.

Chapter 10

140. *Estes Park Trail,* "Combs Wins Ski Title."
141. *Estes Park Trail,* "Estes Park's First Annual Ski Tournament."
142. Ibid., "Crawford and Wren Enter Ski Tourney."
143. Smith, "Old Winter Haunts."
144. *Estes Park Trail,* "Winter Sports Begin Today at Fern Lake."
145. Smith, "Fern Lake Lodge."
146. Bronski, *Powder Ghost Towns.*
147. McFadden, "About Rist Canyon."
148. Brown, *Ski Hidden Valley.*
149. Ibid.
150. Ibid.
151. Way, "Rocky Mountain National Park."
152. Brown, "About Hidden Valley."
153. Ibid.
154. Colorado Ski Country USA, *Manual of Colorado Skiing,* Season 1963–1964.
155. Colorado Visitors Bureau, *Manual of Colorado Skiing.*

Chapter 11

156. Gilpin Historical Society. "Apex."
157. Jones, "A Pair of Ghosts—Apex and Its Ski Area."
158. Ibid.
159. Gilpin Historical Society, "Apex," 1.
160. Ibid.
161. Ibid.

Chapter 12

162. *Longmont Ledger,* "Ski Tournament Success."
163. *Boulder Daily Camera,* "Nederland Ski Area."
164. Ibid., Summary of Ski Stories and Ski Files.
165. Ibid., "Here Are Hints."
166. Ibid., "Buffs Building 49-Meter Jump at Rogers Park."

Chapter 13

167. *Greeley Journal,* "Sharktooth Ski Area Opens: Fun."
168. Fasano, "Ski Slope May Return to Weld."
169. Karlson, "Ski Greeley!"
170. http://www.poudretrail.org/trail-tour/geography (accessed June 1, 2014).

Chapter 14

171. Bjorkland, "That Horrible Winter."
172. Dyer, *Snow-Shoe Itinerant.*
173. McMillin, "Lost Ski Areas by Name."
174. Swanson, personal reminiscence.

Chapter 15

175. Historical Society of Idaho Springs, *History of Clear Creek County: Tailing, Tracks, & Tommyknockers,* Denver: Specialty Publishing, Inc., 1986.
176. Ibid.
177. Partners for Access to the Woods, "MP 255-256: The Empire Toll Gate and Glen Arbor," 2012.
178. Bronski, *Powder Ghost Towns.*
179. Chamberlin, personal interview.
180. Smith, "Old Winter Haunts."
181. Smith, "Fern Lake Lodge."
182. Fetcher, "Berhoud Pass Ski Area," Colorado Ski History website http://www.coloradoskihistory.com/lost/Bpass.html (accessed July 17, 2014).
183. Tipton, personal reminiscence.
184. Colorado Ski Country USA, *Manual of Colorado Skiing,* Season 1963–1964.
185. Barr, "Nickel Candy Bar of Skiing."
186. Blevins, "Berthoud Pass Ski Lodge Torn Down."
187. Colorado Ski Country USA. *Manual of Colorado Skiing,* Season 1963–1964.
188. Fosha, interview.
189. Whittington, Tom, and daughters, personal reminiscence.

Bibliography

ARTICLES

Advertisement. "Grand Fourth of July Celebration." *Record Journal of Douglas County*, July 1, 1921.

Barr, Lois. "The Nickel Candy Bar of Skiing." *Empire Magazine*, November 13, 1977.

Bjorkland, Linda. "That Horrible Winter." Excerpt from *Over Boreas Pass*, Park County Local History Archives Newsletter, Issue 1, February 2011.

Blevins, Jason. "Berthoud Pass Ski Lodge Torn Down." *Denver Post* online, June 13, 2005. http://www.denverpost.com/business/ci_2798430 (accessed August 13, 2014).

Boulder Daily Camera. "Buffs Building 49-Meter Jump at Rogers Park." October 16, 1962.

———. "Here Are Hints on the Use of Boulder's New Ski Jump, 10 Miles Up the Canyon." January 28, 1948.

———. "Nederland Ski Area to Open This Week-end: Tows, Runs in Good Shape; Area is Boulder's Closest Ski Center." December 6, 1951.

———. Summary of Ski Stories and Ski Files, 1988.

Caption under photographs attributed to Knutson-Bow. "Ski Conditions at Their Best." Probably in *Colorado Springs Gazette*, February 6, 1948.

City of Denver. "The National Ski Tournament: Expected to Popularize Winter Sports in Mountain Parks." *Municipal Facts* 4, nos. 1–2 (January–February 1921).

Daily Journal. "Telluride Should Have Ski Club, Says Champion Ski Jumper."
April 10, 1923, 1.

Estes Park Trail. "Combs Wins Ski Title." Friday, January 25, 1924.

———. "Crawford and Wren Enter Ski Tourney." March 4, 1949.

———. "Estes Park's First Annual Ski Tournament Is Pronounced by
Participants a Decided Success." Friday, March 21, 1921.

———. "Mr. Tschudin Sees Great Opportunity in Winter Sports for Estes
Park." January 25, 1924.

———. "Winter Sports Begin Today at Fern Lake." Friday, March 10, 1922.

Fasano, T.M. "Ski Slope May Return to Weld." *Windsor Tribune,* December
11, 2004.

Gilpin Historical Society. "Apex." *The Nugget,* December 2009.

Greeley Journal. "Sharktooth Ski Area Opens: Fun." December 17, 1971.

"A History of Winter Sports in Jefferson County." *City and Mountain Views,*
no. 102 (Winter 2013–2014): 23. http://www.jbgcloud.com/books/
cityviewwinter/index.html#22 (accessed July 14, 2014).

Howelsen, Carl. "Interesting History of Winter Sport in Colorado: 'Father
of Howelsen Hill' at Steamboat Springs, Where World's Remarkable
Records Are Made Each Year, Reviews Progress of Skiing in This
Country." *Steamboat Pilot,* April 11, 1917.

Jenkins, Mark. "A History of Skis." *National Geographic* (December 2013):
90–95.

Jones, Linda. "A Pair of Ghosts—Apex and Its Ski Area." *Colorado Gambler,*
December 12–18, 2000.

Karlson, Diane. "Ski Greeley!" City of Greeley Museums Collections.

Kisling, Jack. "Doggone It! There's No Joy in Oak Creek: Flighty Casey
Ruined Ski Festival." *Denver Post,* March 13, 1985.

Lay, Jennie. "Ghost Turns: Lost Ski Areas Found." *Steamboat Magazine*
(Holiday 2007).

Longmont Ledger. "Ski Tournament Success." Friday, March 16, 1923.

McMillin, John. "Mountains of Memories, Mountains of Fun: A History of
Skiing in Jefferson County." *Historically Jeffco* 10, no. 18 (1997), published
by the Jefferson County Historical Commission. http://historicjeffco.files.
wordpress.com/2013/06/1997histjeffco18.pdf (accessed July 14, 2014).

Meyers, Charlie. "Arapahoe East Coming Soon." *Denver Post,* Sunday,
December 26, 1971.

———. "Jump Back at Arapahoe." *Denver Post,* Thursday, December 6, 1979.

Middle Park Times. "Grand County's Winter Sports Carnival to Be Held
at Hot Sulphur Springs on Feb. 10th, 11th and 12th: The Ladies of Hot

Sulphur Springs Will Probably Give an Exhibition of Ski Jumping During the Big Carnival of Winter Sports." February 2, 1912.

———. "Judge Kennedy's Ride," January 30, 1914.

———. "Planning of Second *Annual* Winter Carnival by Winter Sports Club." January 3, 1912.

———. "Skisport." February 18, 1916.

Nicklas, Tim. "Lost Ski Areas of Grand County." *Spoke*, Grand County Historical Association publication (Spring 2014).

Partners for Access to the Woods. "MP 255-256: The Empire Toll Gate and Glen Arbor." 2012.

Sanborn, Don, Don Kallaus and Don Ellis (Don Gang). "Skiing on Pikes Peak During and After World War II," *West Word* 29, no. 3 (April 2014).

Smith, Woody. "Fern Lake Lodge." *Trail & Timberline*, no. 1017 (Winter 2012).

———. "Old Winter Haunts of the CMC: Berthoud Pass." *Trail & Timberline*, no. 1021 (Winter 2013).

"So Little Time For Such True Friends," *Steamboat Magazine* (Summer/Fall 2000).

Vandelinder, John. "Cathy Cisar Hill a Frequent Destination for Sledding Enthusiasts." *Craig Daily Press* online, http://www.craigdailypress.com/news/2009/jan/03/cathy_cisar_hill_frequent_destination_local_sleddi (accessed July 27, 2014).

Way, L.C. "Rocky Mountain National Park." *Estes Park Trail Talk*, August 6, 1920.

Yampa Leader. "Yampa Ski Club to Be Organized," Friday, October 20, 1916.

Books

Bronski, Peter. *Powder Ghost Towns: Epic Backcountry Runs in Colorado's Lost Ski Resorts.* Berkeley, CA: Wilderness Press, 2008.

Cairns, Mary Lyons. *Grand Lake in the Olden Days.* Denver, CO: World Press, Inc., 1971.

Coleman, Annie Gilbert. *Ski Style: Sport and Culture in the Rockies.* Lawrence: University Press of Kansas, 2004.

Dyer, John. *The Snow-Shoe Itinerant: An Autobiography.* Cincinnati, OH: Cranston & Stowe, 1891.

Fay, Abbot. *A History of Skiing in Colorado.* Ouray, CO: Western Reflections, Inc., 2000.

Godfrey, Anthony. *From Prairies to Peaks: A History of the Rocky Mountain Region of the U.S. Forest Service*. Washington, D.C.: United States Department of Agriculture, Forest Service, 2012.

Hamilton, Penny Refferty. *Images of America: Around Granby*. Charleston, SC: Arcadia Publishing: 2013.

Historical Society of Idaho Springs. *History of Clear Creek County: Tailing, Tracks, & Tommyknockers*. Denver, CO: Specialty Publishing, Inc., 1986.

Kingery, Hugh E. *The Colorado Mountain Club: The First Seventy-Five Years of a Highly Individualized Corporation, 1912–1987*, Evergreen, CO: Cordillera Press, 1988.

Taylor, Jean, and Cott, Ann. *A Century in the Shadow of Pikes Peak: Don Lawrie, His Mountain, His Life*. Pueblo, CO: PaperWork, Inc., 1999.

E-MAIL CORRESPONDENCE

Brown, Brian. "About Hidden Valley." April 21, 2014.

Fetcher, Bill, to Caryn Boddie. "About Grand Lake Ski Areas." August 8, 2014.

———. "About Hospital Hill." August 8, 2014.

———. "About Kremmling Hill." August 8, 2014.

———. "About Leland Jackson-Carmichael-Ouray Ranch Ski Hill." August 8, 2014.

———. Expanding thoughts on ski hills, how they are defined, why they closed. August 8, 2014, following interview with him in April 2014.

Fetcher, Bill, to Peter Bronski. "About Baker Mountain." October 28, 2012.

McFadden, Leslie, USFS, to Sue Struthers and Larry Fulenkamp. "About Rist Canyon Hill." May 27, 2014.

FILM

Brown, Brian. *Ski Hidden Valley, Estes Park: A Documentary Film*. BrownCow Productions, Estes Park, CO.

JOURNALS/MANUALS

Colorado Ski Country USA. *Manual of Colorado Skiing and Winter Sports.* Season 1963–1964.

————. *Manual of Colorado Skiing and Winter Sports.* Season 1962–1963.

Colorado Ski Information Center. *Manual of Colorado Skiing and Winter Sports 1962–63 Season: Ski at the Top of the Nation.*

Colorado Visitors' Bureau. *Manual of Colorado Skiing.* Denver, CO, 1965–1966.

Grand County Historical Association Journal 4, no. 1 and 9 [second printing] (March 1988). Cited as GCHA.

LECTURES

Howelsen, Leif. Lecture at the Tread of Pioneers Museum, August 22, 2003.

PAPERS

McMillin, John. "Lost Ski Areas by Name." Unpublished, April 4, 1999.

PERSONAL INTERVIEWS

Armstrong, Maggie. Telephone interview. Littleton, Colorado, July 26, 2014.

Chamberlin, Brad. Denver, Colorado, April 28, 2014.

Fetcher, Bill. Steamboat Springs, Colorado, April 19, 2014.

Fosha, Ken. Drowsy Water Ranch, Colorado, March 29, 2014.

Herold, Rita, and Paul Bonnifield. Yampa, Colorado, April 19, 2014.

Nicklas, B. Tim. Grand County Museum, Colorado, February 22, 2014.

Saenger, Eric. Golden, Colorado, July 6, 2014

Swanson, Erik. Fairplay, Colorado, May 17, 2014.

Taussig, Reed. Telephone interview. Littleton, Colorado, July 26, 2014.

PERSONAL REMINISCES

Cork, Dean. "Where Skis Were Long and Lines Were Short." Oak Creek Museum, undated.

Hopkins, C. Lew. "A Brief History of Early Colorado Ski Areas Developed and Operated by Covert L. Hopkins." Hiwan Homestead Museum collection, December 9, 1995.

Sanborn, Don, Don Kallaus and Don Ellis (Don Gang). "The History of Skiing on Pikes Peak." Ute Pass Historical Society, April 15, 2014.

Tipton, Nancy. Centennial, Colorado, Caryn Boddie files, March 10, 2014.

Whittington, Tom, and daughters. Littleton, Colorado, Caryn Boddie files, April 12, 2014.

WEBSITES

Colorado Ski and Snowboard Museum Hall of Fame. http://www.skimuseum.net/halloffame.

Colorado Ski History. http://www.coloradoskihistory.com.

Colorado Sports Hall of Fame. http://www.coloradosports.org/index.php/who-s-in-the-hall/inductees/item/237-gordon-wren.

El Pomar Foundation. http://www.elpomar.org/who-we-are/our-history/spencer-penrose.

Leitner-Poma. http://leitner-poma.com/front-slider/leitner-poma-historical-timeline/.

Moffat Railroad Museum. http://www.moffatroadrailroadmuseum.org/moffatrdmaps.html.

National Geographic. http://ngm.nationalgeographic.com/2013/12/first-skiers/ski-history-interactive.

Poudre Trail. http://www.poudretrail.org/trail-tour/geography.

Steamboat Library. http://www.steamboatlibrary.org/about-us/history/who-was-buddy-werner.

Steamboat Resort Real Estate. http://steamboatresortrealestate.com/sales-trends/stagecoach-colorado.

Index

A

accidents 26
Aggies 82, 118
Airport Hill 63
Allen, Alfred 141
Allenspark 137
Allens Park Ski Club 82
all-military ski meet 109
Alpenbach 162
Alpine skiing 21, 114
Apex 133
Arapahoe East 97
Arlberg, Austria 114
Arlberg Club 83
Armstrong, Maggie 39, 52
Atkinson, John, Jr. 111

B

Baker Mountain 34, 46, 50, 52, 53, 79
Balent, Ralph 133
Bardley, Steve 41
Barr, Lois 159
Baumgarten, Idelia 35
Beattie, Bob 145

Beck, Dale 80
Berthoud Pass 155
Berthoud Pass Ski Area 41
Blevins, Jason 161
Bonnifield, Paul 64
Boulder 141
Boulder County 136
Boyle, Harriet Proctor 21
Boys Club 63
Bradley, Steve 141
Bronski, Peter 68, 112, 125, 126, 153, 161
Brown, Brian 130
Buchtel, Henry 94
Bungalow Hill 35, 37, 39
Bureau of Reclamation 26, 46
Button, Horace 21, 35, 37

C

Cameron Pass 77
Cameron Pass Ski Club 126
Cardinal Hill 140
Carlson, George C., Jr 43
Casey (Bassett hound) 67

INDEX

F

Fall River Road 123
Farrar, Duane 47
Farrington, Eddie 64
Fender, Loren 89, 94
Fern Lake 123
Fern Lake Lodge 123
Fetcher, Bill 11, 34, 39, 41, 46, 53, 68
Fetcher, John 71
Fig Leaf Ranch 103
Flying Norseman, the 56
Flying Norwegian, the 63. *See*
 Howelsen, Carl
Follet Ranch 79
Fort Collins 118
Fosha, Ken 43, 45, 162
Fosha, Randy Sue 43
Fowler, John 102
Frosty Basin 41, 45, 46
Fun Valley 97

G

Gammill, Carl C. 158
Garst, Clarence (Ike) 159
gas rationing
 effect on ski hills 84, 95
Genesee Mountain 84
Genesee Mountain Park 57
Geneva Basin 45, 162, 163, 164
geography 16
Georgetown 163
Gilpin County 133
Gilpin Historical Society 133
Glen Arbor Lodge 153
Glen Cove 105
Goe, Bill 133
Gould Ski Hill or North Park Ski Hill 78
Granby 34, 41, 43, 45, 47, 162
Grand County 21, 29, 30, 34, 35, 39,
 52, 162
 museum 30
Grand County Historical Association 46
Grand Lake 29, 34, 43, 47

Grant family 157
Great Depression 84
Greeley 147
Groswold, Thor 41, 84, 104, 105,
 113, 143
Guanella, Ed 162
Guanella family 153
Guanella, Paul 153

H

Hahn's Peak 74
Hampton, Jerry 52
Hansen, Hans 138
Hardy, Ben 103
Haugen, Lars 22, 105, 138
Hayden 73
Herold, Rita 63
Hidden Valley 26, 118, 122, 128, 129,
 130, 131
Historical Society of Idaho Springs 152
Hix, Donald 133
Hix, Horace 133
Hobbs, Mary Jean 143
Holderness, Jack 73
Holderness Ranch 73
Holiday Hills 111
Holly Sugar Corporation 107
Homewood Park 84, 91
Hopkins, C.L. 138
Hopkins, Covert 89, 94
Hopkins, Lew C. 89
Hospital Hill 72
Hot Sulphur Springs 29
Hottel, Bill 139
Howelsen, Carl 30, 54, 59, 62, 63, 77,
 82, 84, 85, 87, 102, 155
Howelsen, Leif 56, 59, 87
Huntington family 157
Huntington, Sam 157
Hurt, Monte 128

I

Idaho Mountain 134
Idlewild 34, 49, 50

181

Norwegians 19
Norwegian snowshoes 19, 21, 29, 30

O

Oak Creek 65
Old Man Mountain 120
Omtvedt, Ragnar 61

P

Palm, Robert 30
Park County 149
Pearl Lake 74
Pease Hill 50, 52
Penrose, Spencer 104, 105, 115
Perchlik, Mayor 148
Perchlik, Sylvia 148
Perry, Marjorie 59, 62
Peyer, John 30, 31
"Phenomenal Snowman" 115
Pikes Peak 112
Pikes Peak Auto Highway 104
Pikes Peak Ski Club 83, 105, 115
Pine Springs Ski Hill 79
Pioneer Ski Club 82
Poma 43, 68, 71, 75, 97, 98, 110, 151
Porter, Glenn 139

R

Rainbow Valley Ranch Ski Area 112
Ralston family 84
Rilliet Hil 93
Rilliet Park Association 94
Rist Canyon 128
Rocky Mountain National Park 22, 26,
 118, 120, 123, 128
Rocky Mountain National Park Ski
 Club 82
Rocky Mountains 16
Rogers Park 143
Rollins Pass 30
rope tows
 Airport Hill 63
 Berthoud 157
 Cathy Cisar Winter Playground 81

Chautauqua 141
Clark Community Hill 71
Cowboy Peak 65
Elk Park 109
Emerald Mountain 68
first west of Mississippi 105
Fun Valley 97
Glen Cove 105
Gould Ski Hill 78
Hidden Valley 131
Holderness Ranch 73
Holiday Hills 111
Hospital Hill 73
Jackson County 78
Mount Lugo 95
New Mercury Ski Course 150
passed around 34
Pine Springs Ski Hill 79
Rist Canyon 128
Sharktooth 148
St. Mary's Glacier 155
Tabernash 46
Tenderfoot Mountain 111
Routt County 59

S

Saenger, Eric 74
Sanborn, Don 105
Scandinavians 19, 21, 24, 29, 64, 91, 114
Schaeffler, Willy 88
Schmidt, Angell 30, 59
Seven Utes Mountain 77
Shafroth family 157
Sharktooth 148
Sheafor, Doug 102
Shelton, Josephine 83, 88
Silver Spruce Ski Club 83, 104
Silvola, George 111
Sixteenth National Ski Tournament of
 America 85
ski celebrities. See individual names
skijoring 21, 31, 73
ski jumping 19, 21, 30, 31, 34, 35, 37,
 46, 56, 57, 59, 83, 84, 88, 91,
 101, 102, 103, 104, 105, 108,

About the Authors

Caryn and Peter Boddie have been skiing since childhood and enjoying Colorado for years. Caryn learned to ski at Loveland and Vail while Peter learned in Connecticut. Previously, they created the original *Hiker's Guide to Colorado, Hiking Colorado I* and *Hiking Colorado II*, which took them down hundreds of miles of trails. They still love traveling the state and talking to people. Peter works as a hydrologist and a scientist, focusing on the natural sciences, and as a geographer. Caryn works as an editor and communications person and writes on a variety of projects. They live in South Jefferson County.

Author gets help from an instructor in this depiction of her as a skier in the 1960s. *Caryn Boddie collection.*